		*				
*						

minimalist interiors

Author

Paco Asensio

Editor

Quim Rosell

Text

Richard L. Rees

Design

Mireia Casanovas Soley

Layout

Jaume Martínez Coscojuela

1999 © Loft Publications s.l. and HBI, an imprint of HarperCollins Publishers

Hardcover ISBN: 0-688-17487-6 Paperback ISBN: 0-8230-6636-3

Printed in Spain

Editorial project:

LOFT publications Domènec 9, 2 -2 08012 Barcelona. Spain Tel.: +34 93 218 30 99 Fax: +34 93 237 00 60

e-mail: loft@interplanet.es www.loftpublications.com First published in 1999 by **LOFT** and **HBI**, and imprint of HarperCollins Publishers 10 East 53rd St. New York, NY 10022-5299

> Distributed in the U.S. and Canada by Watson-Guptill Publications 1515 Broadway New York, NY 10036 Telephone: (800)-451-1741 (732)- 363-4511 in NJ, AK, HI Fax: (732)-363-0338

Distributed throughout the rest of the world by HarperCollins International 10 East 53rd St. New York, NY 10022-5299

No part of this book may be reproduced or transmitted in any form or by any means electronic or mechanical including photocopying, recording, or by any information storage and retrieval system, without permission in writing from the publisher.

Akira Sakamoto 800 The Hakuei house John Pawson 018 The Moerkerke house Vincent Van Duysen 026 House in Mallorca Simon Conder 032 Alterations to an apartment Rataplan 038 House in Vienna Grupo LBC 044 House in el Pedregal de San Ángel Andrade + Morettin 048 Coelho house Adolf Krischanitz 054 Sperl house Philippe Madec 062 Extension of a single-family house Sauerbruch + Hutton 068 The H house Buzacott & Ocolisan Associates 076 Remodelling of the Tait Doulgeris Shigeru Ban 080 The house without walls Dirk Jan Postel 088 Glass house in Almelo Alberto Kalach 094 Palmira house Claire Bataille & Paul Ibens 102 Apartment in Knokke João Alvaro Rocha 108 House in Viana do Castelo Peter Marino 116 Private residence Procter & Rihl 120 Apartment in Soho Josep Llobet 126 Alterations to and extension of Montserrat/Quellos house Stéphane Bourgeois 130 House in Ibiza José Tarragó 138 House in "La Azohía" Kazuyo Sejima 144 The M house Engelen + Moore 152 Price / O'Reilly house Picado- De Blas- Delgado 158 Country house in los "Cerros de la Santa" Vicens / Ramos 162 The Huete house Hiroyuki Arima 168 3R house

Both in theory and practice, recent nineties architecture may be placed in a broad, diffuse context that does not lend itself to precise definition. Even so, it has kept a place for one of the trends that has been applied progressively as a response to over abundance in the use of certain eclectic idioms and to excessive deconstructivist formalism: Minimalism. When confronted with the term "minimalist architecture", we are bound almost

inevitably to turn to Minimal Art, a contemporary sculpture movement that emerged in North America in the sixties as the reaction to a set of pressures in specific social and cultural media; and especially as a critical response to the artistic climate created by movements of the time such as Abstract Expressionism, Pop Art, and Op Art.

Thus, a diversified artistic output, fruit of an accumulation of radical, challenging research and experimentation, emerged

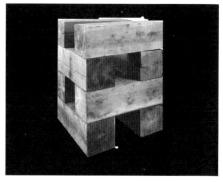

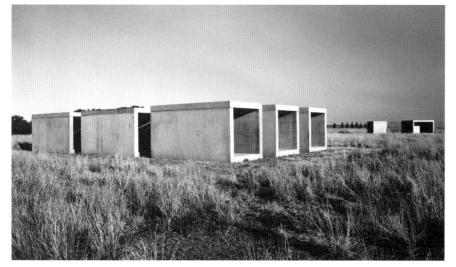

with the purpose of obtaining maximum tension with minimal means. Indeed, Minimal Art as a consolidated strand seeks the essential through the use of simple, elementary geometrical structures as a formal vehicle, and through the absence of decorative elements. In this way, all allusions or references are excluded, except in the repetition of forms as a physical presence in a specific place — a clear allusion to the process of industrial production in series — or the choice of the nature of the material (either conventional or industrial) in order to set up relationships with the location, the site, the mass, the surroundings, and so on. In general terms, Minimalism is based on a process of

reduction of architecture down to its essential concepts of space, light and form, rather than on mechanisms of subtraction, negation, or absence of ornament, or on a eulogy of puritanism. Even so, a superficial reading of this might lead to the mistaken idea of predetermined appearances or a series of conventions (such as white monochrome or the cult of the void), which would enormously oversimplify the complexity of the term "Minimalism" and give way to its introduction into any cultural context. Unlike Minimal Art — with its critical sights aimed at preestablished concepts - minimalist architecture - which lacks any kind of social ideology - is an appendix or continuation, with extreme formal abstractions, of some aspects of contemporary architecture, emerging as a widely used tool in current architectural practice, providing examples on the one hand of stringent sophistication in the finishes of materials, and of technical cleanliness on the other. It sets up an intense dialogue with the site and its surroundings (to the extent of transforming them and endowing them with a new identity), and seeks unity through repetition as a guarantee of quality.

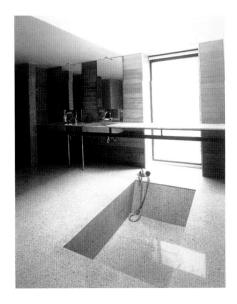

The site is flanked by two streets, one of which forms an intersection with a third. These characteristics were taken into account when it came to designing the house. Across the site. views flow east-west from one street to the other. The eye of the passer by may look freely through the building from the intersection of the streets toward a small wood on the other side. In this way, the volume of the house becomes light and permeable to the eve.

The basic design concept was to represent the exterior in the interior and the interior in the exterior, thereby creating a continuous space between both. The space is articulated by discontinuous walls, the openings of which produce a sensation of fluidity and continuity. People look and talk through the patio and the deck. The movement of the house's occupants can be glimpsed behind the walls, and thus links are established between interior and exterior spaces. Each room differs from the others by the way it is entered, in its visual relationships, and in the way it is lit, which may be through a skylight, horizontal windows, or narrow slits in the corners.

The house was designed on the basis of the precepts of Minimal Art: the dramatic treatment of the main protagonist, light; the noble materials; the simple forms; and the position of elements in relation to others.

The cladding of the walls that constitute the patio is the same as that of the interior, which reinforces the idea of relation and continuity between interior and exterior. The tree is the only element in the patio, and represents the synthesis of the cycles of nature, of living beings, and of time.

This architecture propitiates silence and reflection, directs thought and the gaze toward minimal things that elsewhere would be smothered by noise.

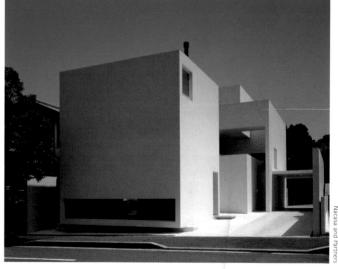

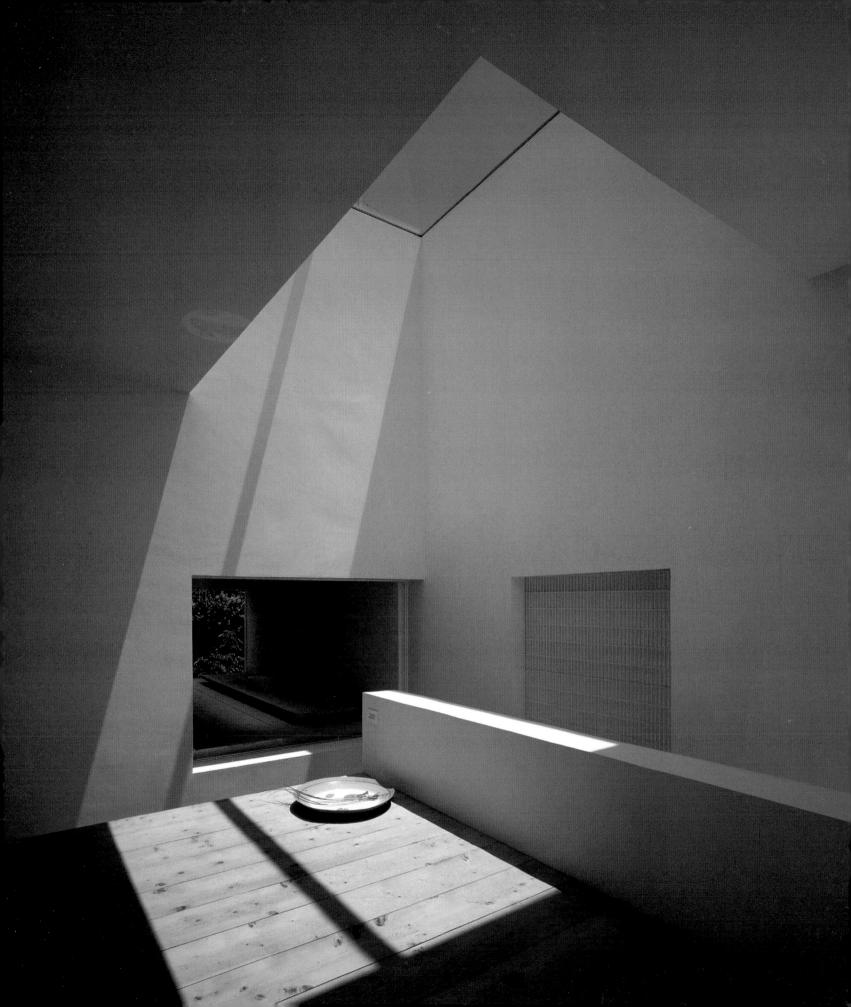

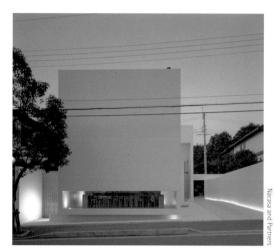

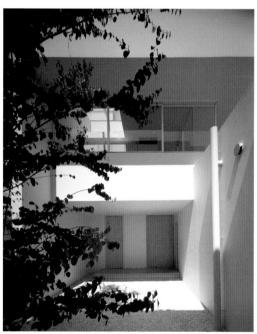

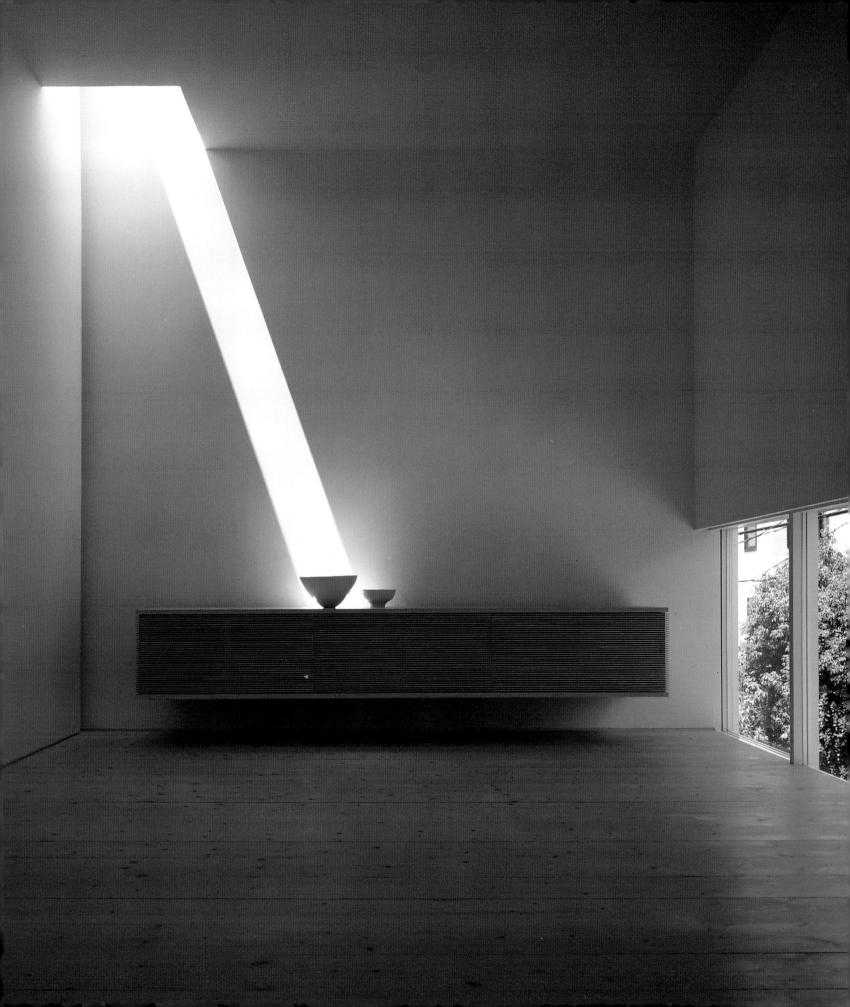

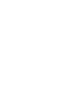

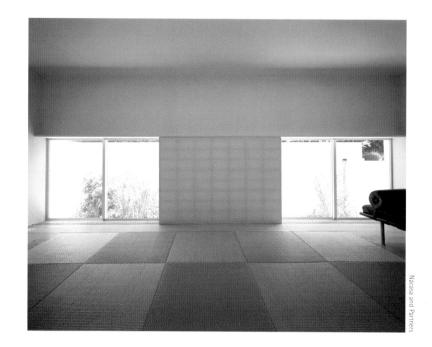

Japanese architecture centers its attention on details that constitute the essence of elements.

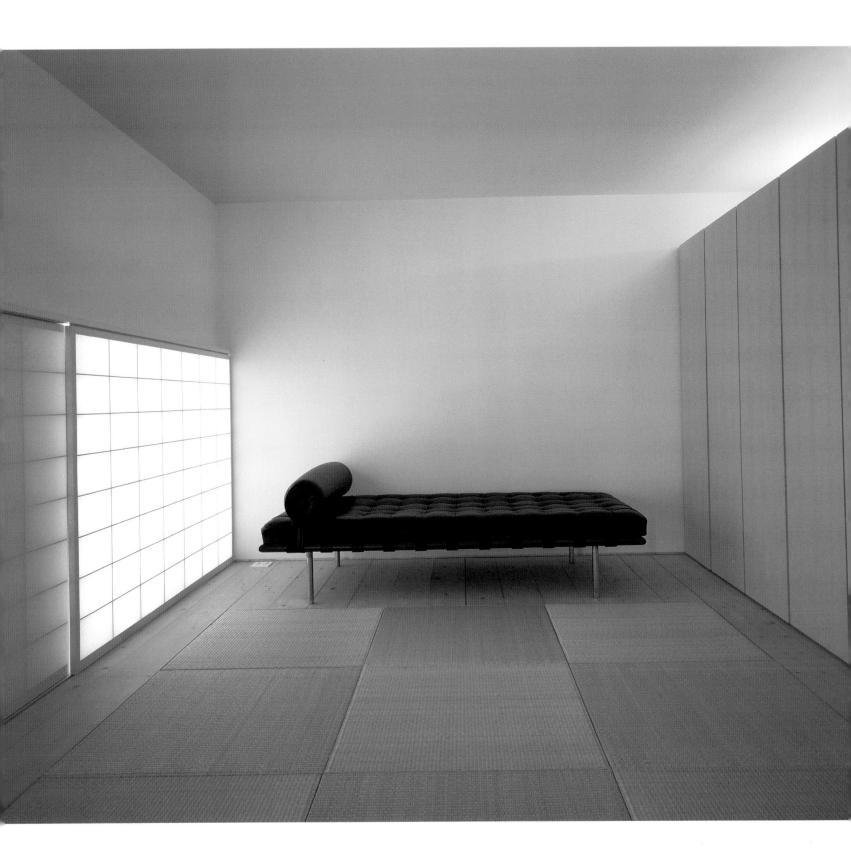

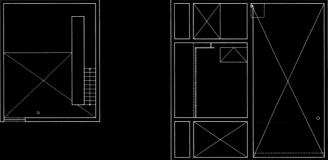

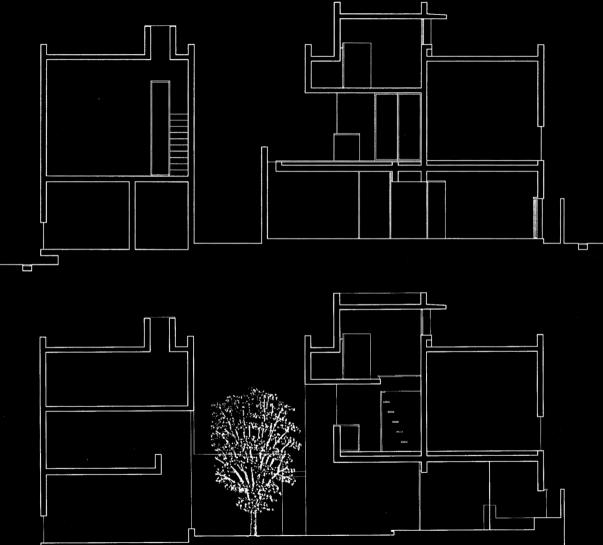

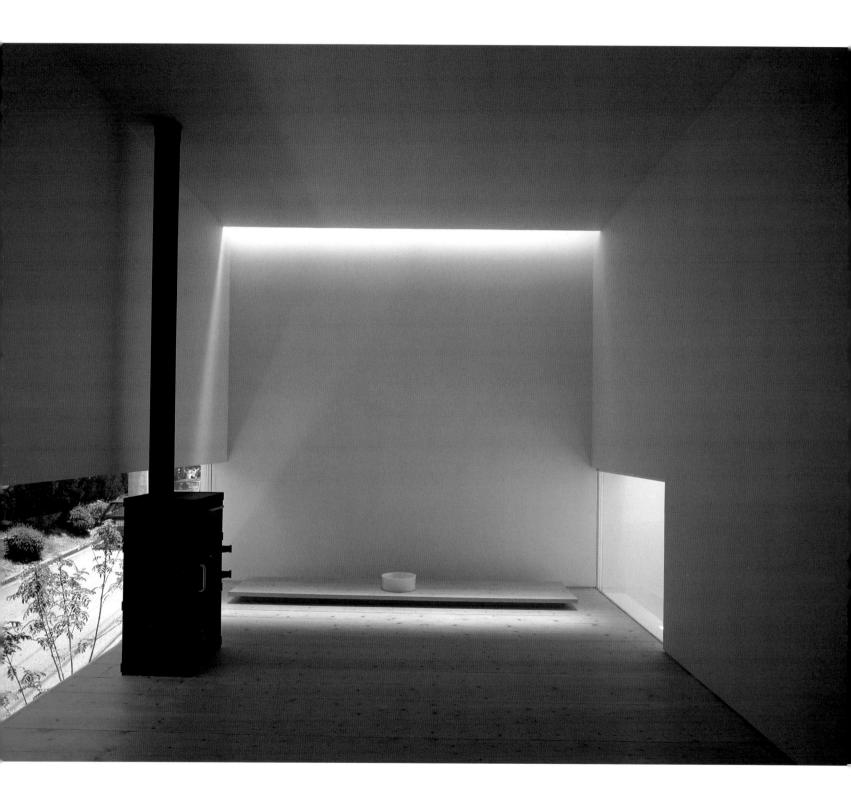

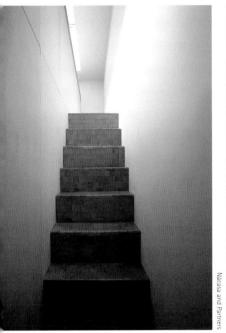

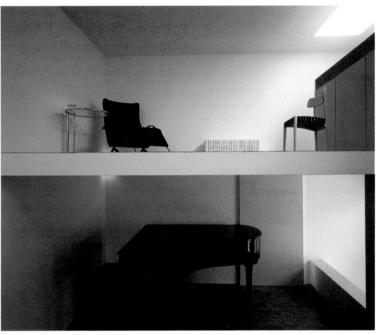

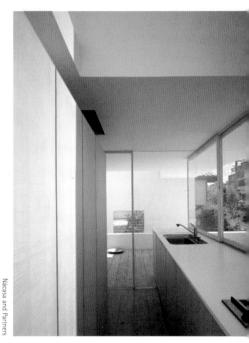

A traditional Victorian mews has been converted into a home for three people. In order to take better advantage of the limited space available, the kitchen, bathroom and stairs were relocated. The bottom floor, which accommodates the kitchen, living room, and dining room, was left as open as possible, like a large continuous space, which may be subdivided if necessary.

Two further elements were added to modify the proportions of the interior space and to meet the functional needs of the dwelling: a chimney wall that contains a staircase, and a wall that both defines and conceals the kitchen, with a stainless steel canopy over the stove. The stair, that squeezes tightly into the chimney wall, is generously lit from the skylight above. The flooring both upstairs and downstairs is of cherry wood, and the walls, all painted white, create a calm atmosphere that fosters reflection. The windows are covered with white fabric that filters the light and visually isolates the home from outside. A simple table, with six chairs by Wegner, and two pairs of armchairs by Christian Liagre are the only visible pieces of furniture.

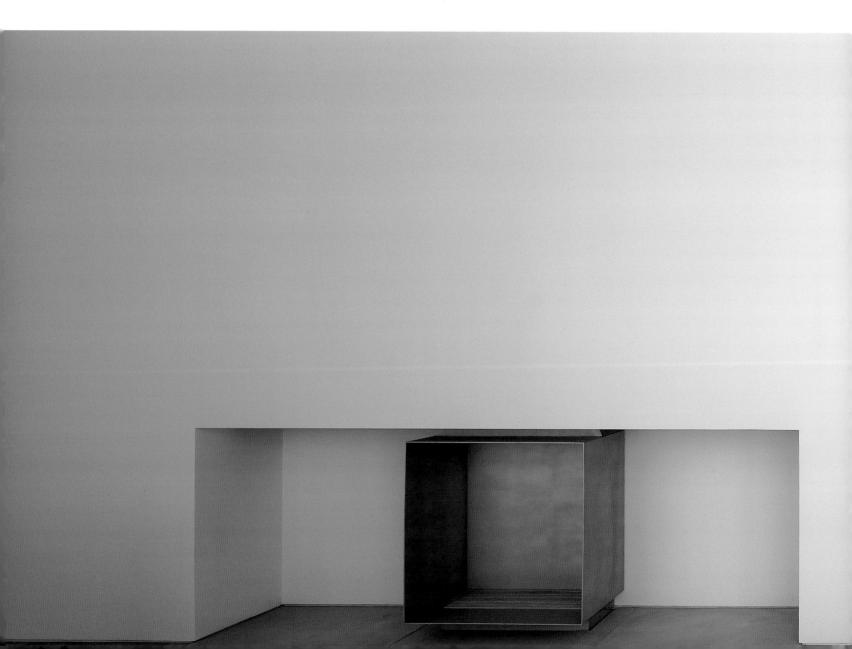

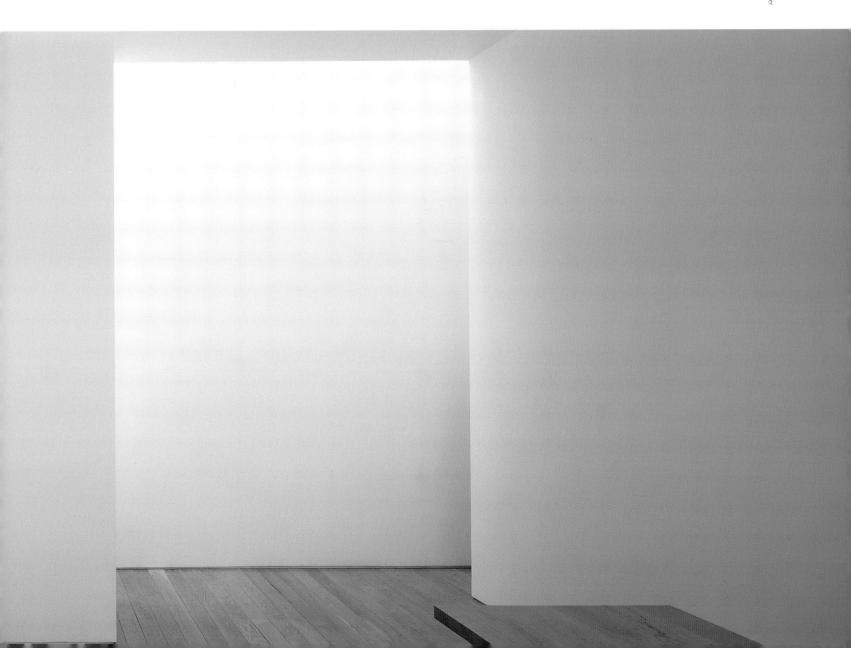

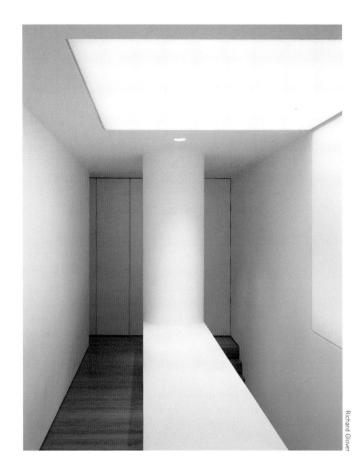

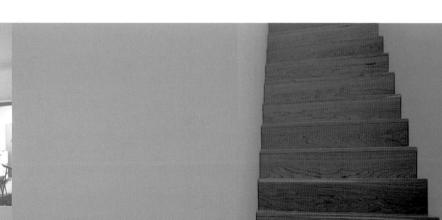

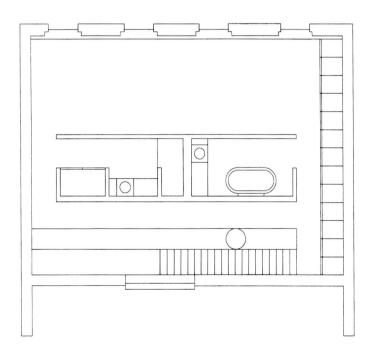

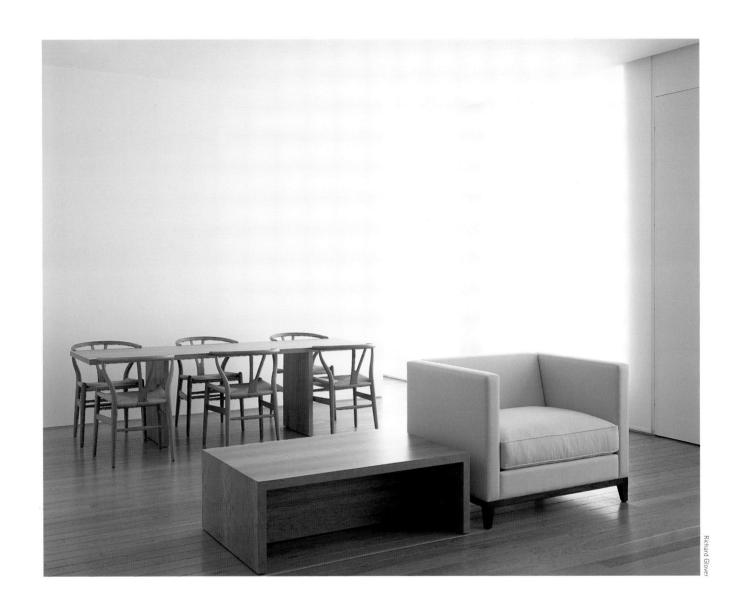

The few pieces of furniture that alter perception of the interior are by distinguished designers: the dining room chairs by Wegner and the armchairs by Christian Liagre.

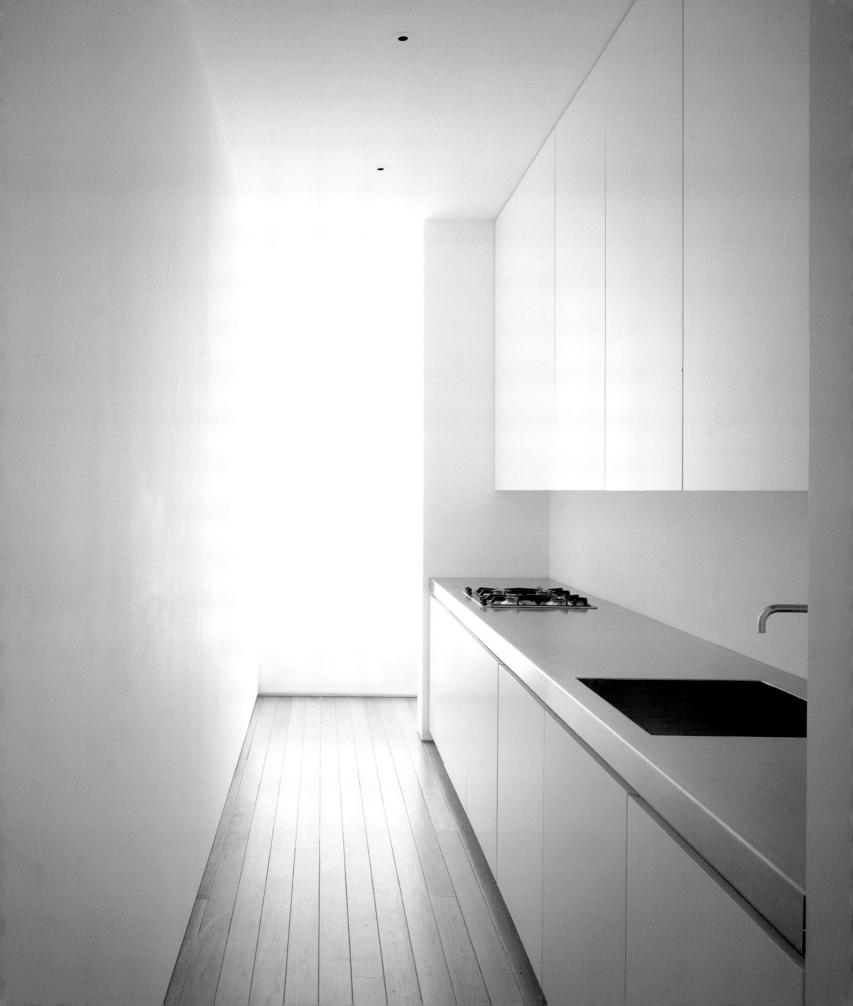

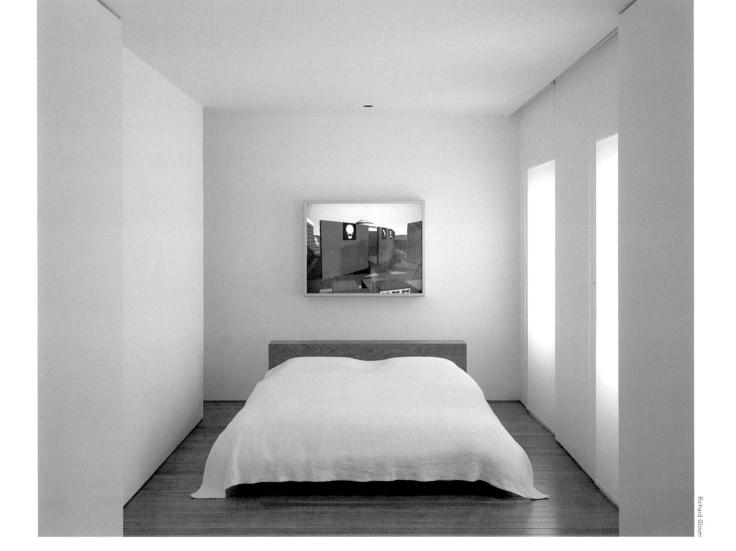

The vertical partitions are designed to appear subtle and light, and are separated by a gap from both the floor and the ceiling.

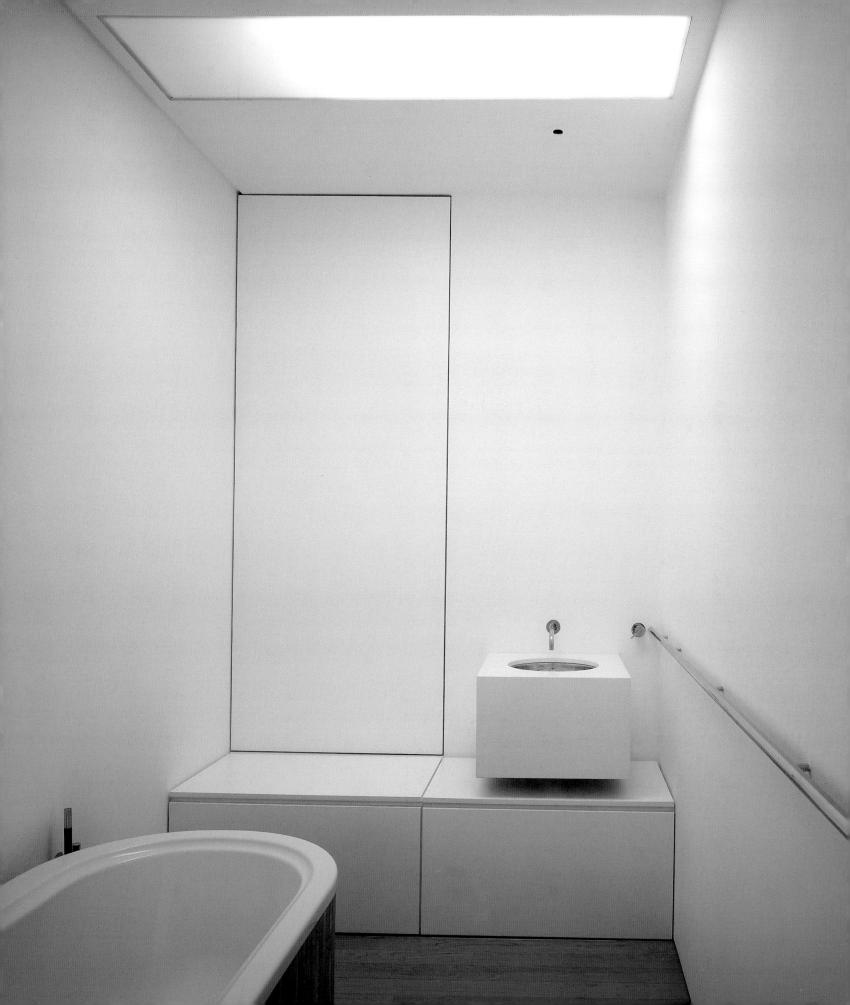

This project is the readaptation of an old traditional Mallorcan house in the island's interior. The facade, together with the two adjacent utility buildings (the janitor's house and the owner's office), have been preserved intact. A sober and very contemporary atmosphere has been created inside.

A strong timber partition separates the house from the janitor's dwelling and delimits a large — though private —patio. The garden was also designed by the architect, who sought to link it directly to the house by means of the paving, a combination of concrete and local stone.

A large, one piece, stone washbasin inserted into a niche attracts attention by virtue of its theatrical quality.

The same atmosphere pervades the entire house. The furniture, stringently designed for each room, has a simple, bare, almost monastic quality. Materials such as wood, ceramics, and marble delicately combine to create an elegant, relaxing atmosphere. The entrance is a room whose walls, covered with timber panels, conceal the entry to the guest bathroom. From here, access is gained to the kitchen-dining room and to the stair that leads to the floor above, which accommodates the bedrooms.

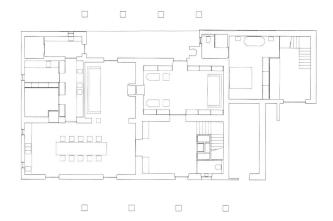

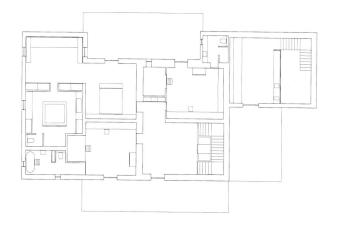

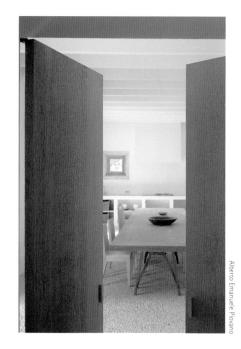

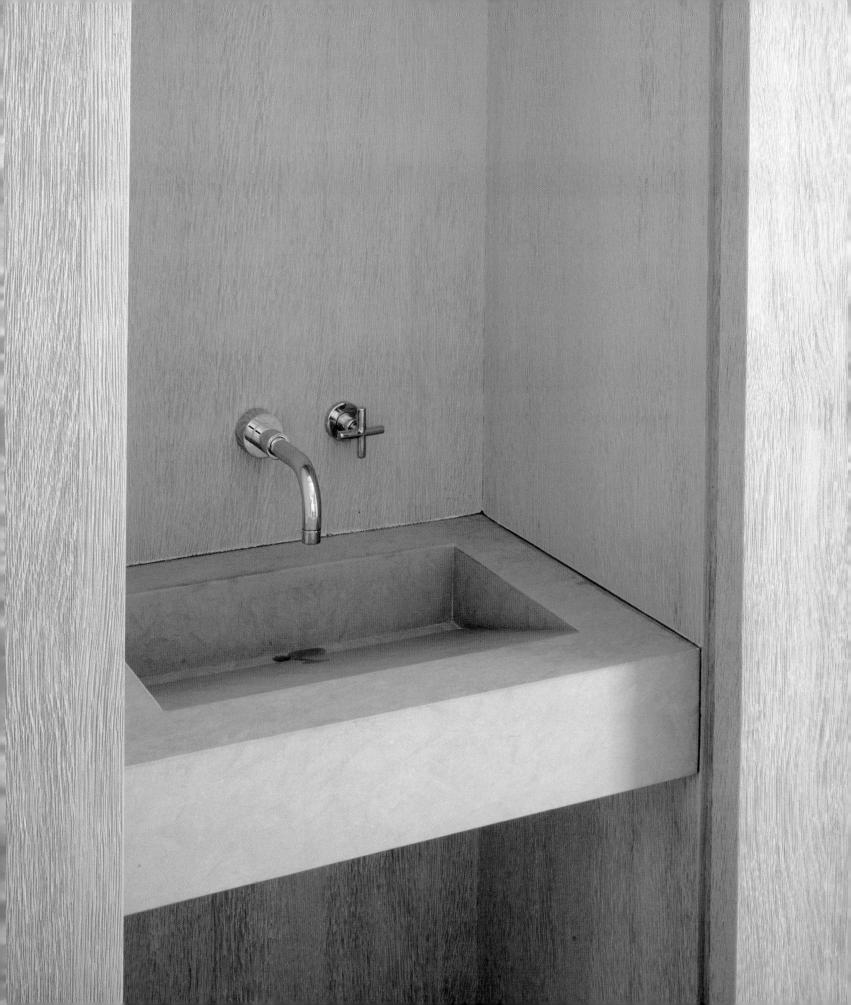

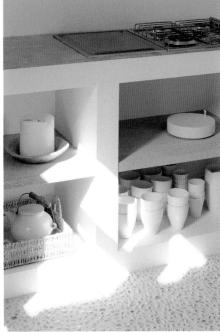

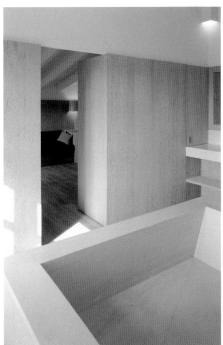

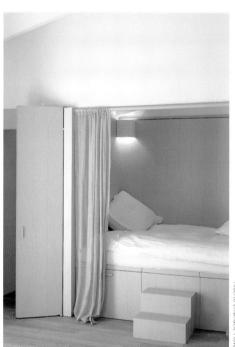

This house reveals that minimalism is a timeless concept, applicable even to architecture of the past.

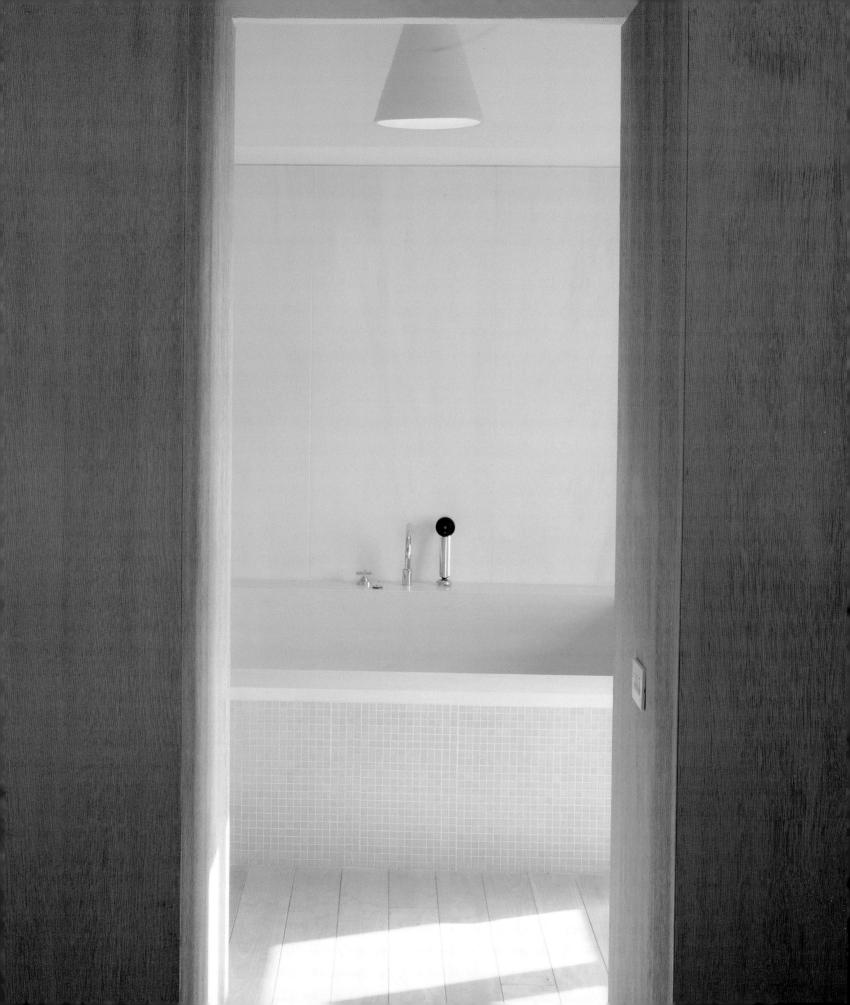

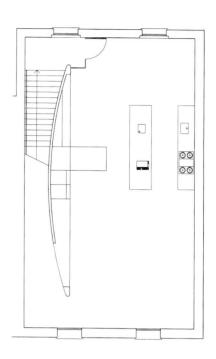

A former fire station in the West End of London has been refurbished as the home of a couple: a musician and a chef. The building was long and narrow, and there were not enough windows to illuminate the whole interior with natural light. The decision was therefore made to build a metal and glass structure on the roof to flood the spaces below with natural light. This glazed ceiling can be opened in summer to convert this space into a pleasant terrace. The dividing screens on all three floors were eliminated, and a stone staircase was built against one of the side walls, which climbs from the ground-floor entrance to the greenhouse on the top floor. A large, wooden, arched-shaped structure acts as storage space and contains the stairs, separating them from the rest of the apartment. The second floor accommodates a vestibule, the master bedroom complete with bathroom, two small bedrooms, and a supplementary bathroom. On this floor the wooden structure contains a large collection of records and also serves as a writing desk.

Much of the furniture was designed by the architect and is built in. This is true for the bed in the master bedroom, the bathtub, and the wooden structure that contains the stairs.

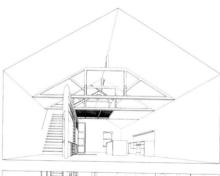

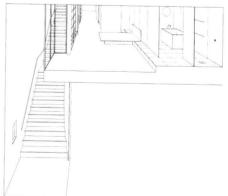

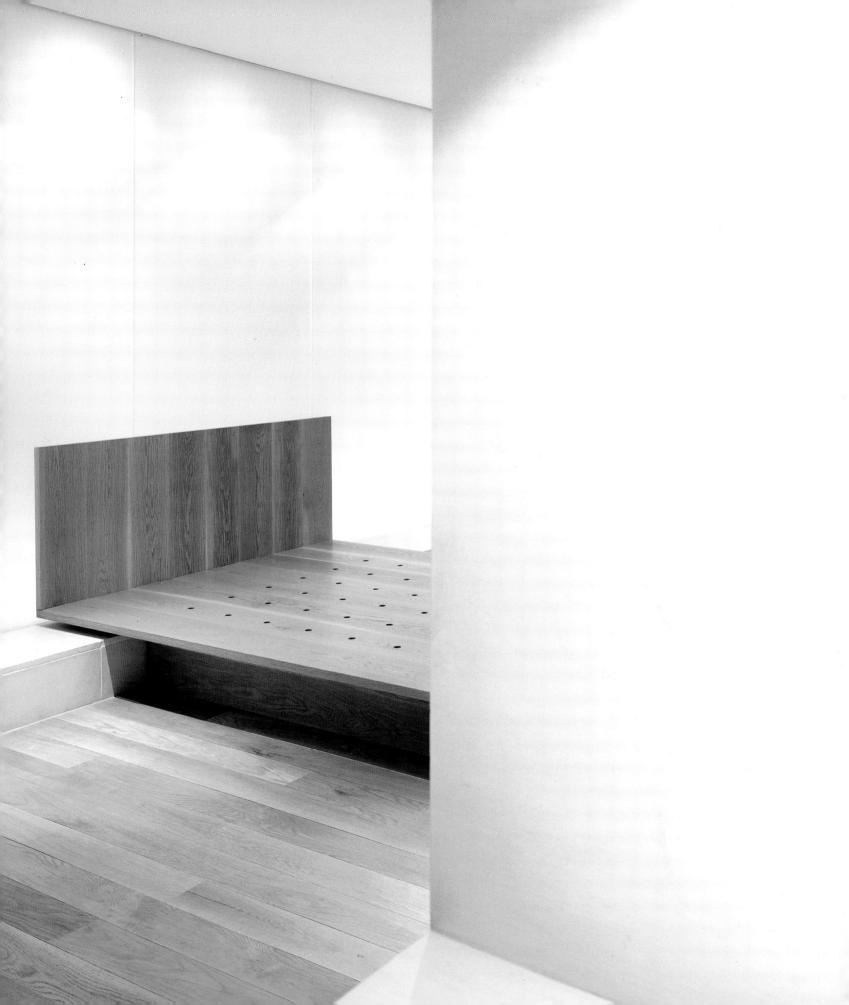

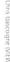

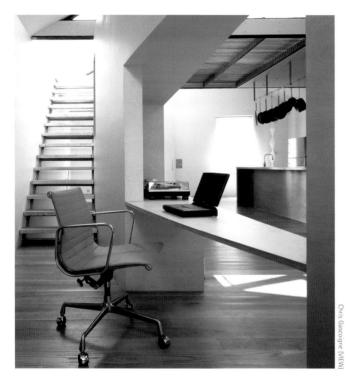

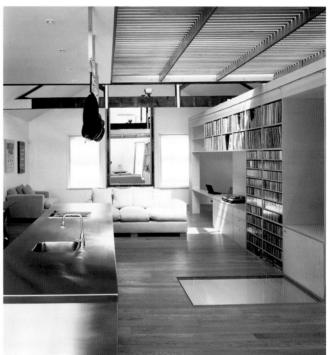

The architect's strategy was to create a solid relationship between space and the objects that occupy it. The best way to achieve this is to design both elements.

The insufficient light provided by openings on the facade made it necessary to build a skylight.

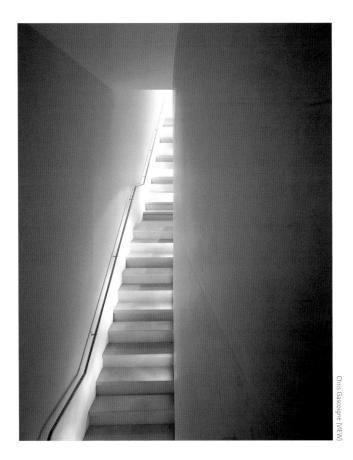

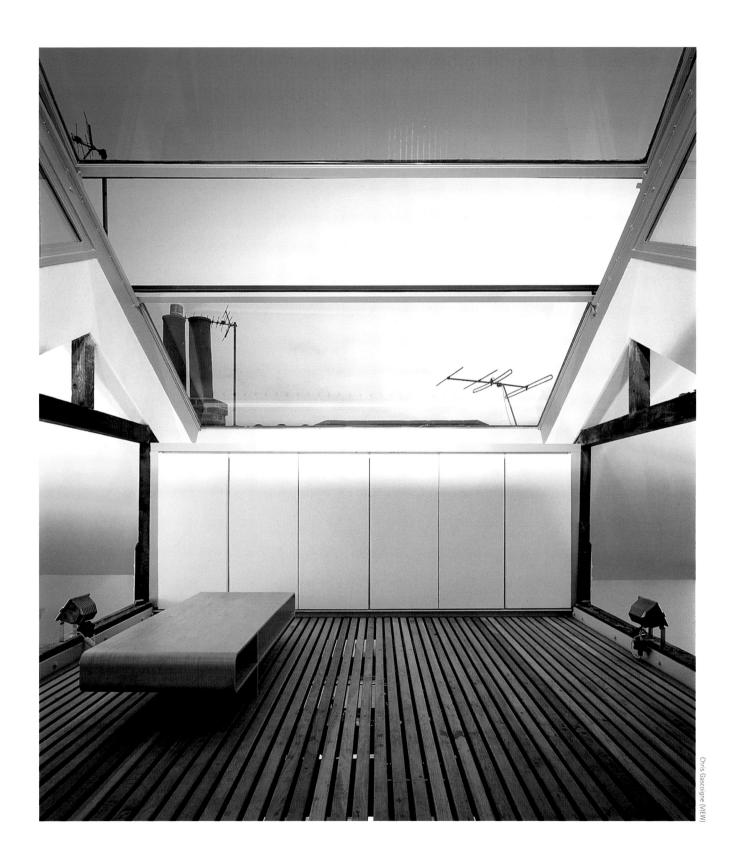

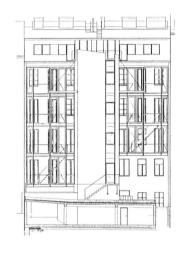

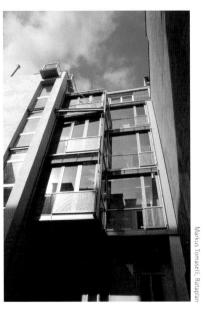

This building, constructed in 1901, was refurbished in 1992. Four duplex homes (of between 430 and 1,620 square feet), and three apartments were built, which together account for 9,200 square feet of living space. Different design criteria were applied inside, since the seven owners participated actively in the process. Many of the homes are oriented southwards, and look over the peaceful interior patio that, together with the garden, were raised half a floor to accommodate a garage. On the ground floor there are two stores.

The street facade was left practically intact, unlike the rear facade, to which an annex-like structure was added. This intervention was conceived as a conservatory for each of the homes. These conservatories need no heating, and in spring and fall they retain solar energy. In summer the entire facade may be closed behind metal shutters.

Two of the duplex homes have their respective stairs in the annex, which in turn is suspended from a hanging metal structure.

The window frames, of large dimensions to suggest the idea of a terrace, are of aluminum. The appearance of the facade may change according to the use the owners make of the metal window shutters. From the exterior, it is possible to subtly perceive the life going on inside the homes.

The original staircase was very dark, whereas now a narrow window running from bottom to top allows light to penetrate the building.

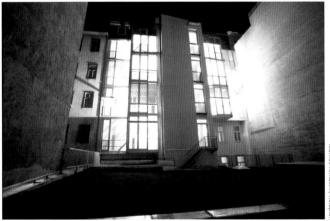

Markus Tomaselli Rata

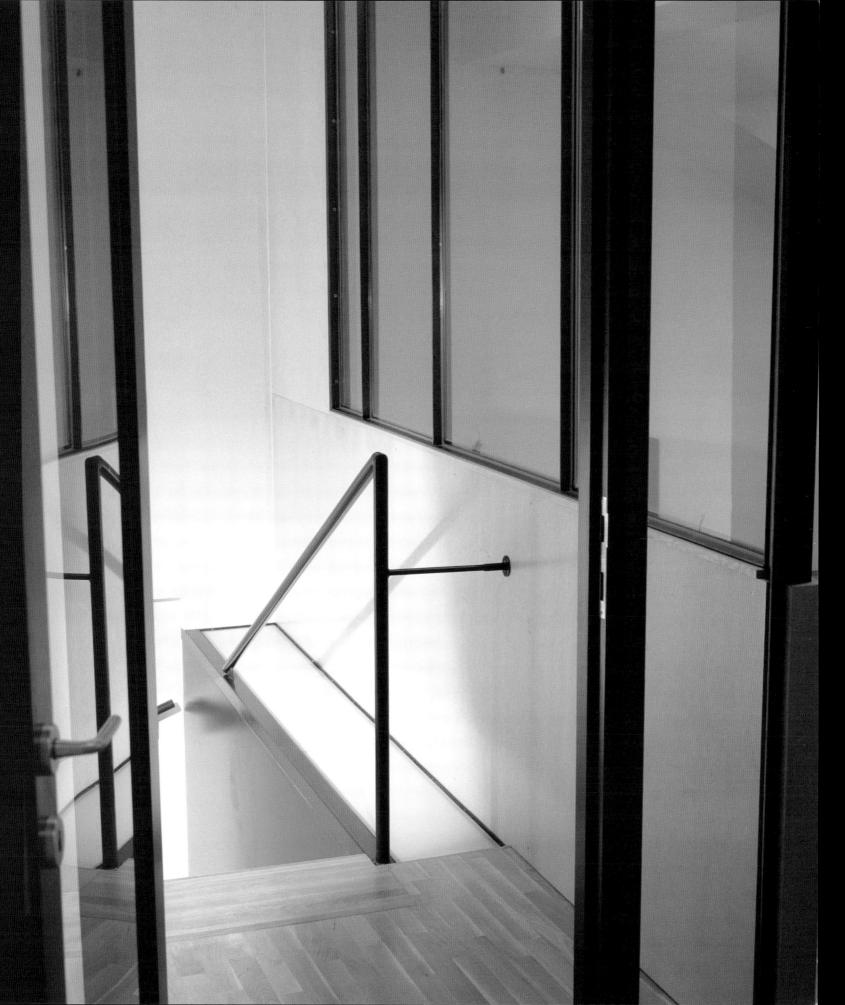

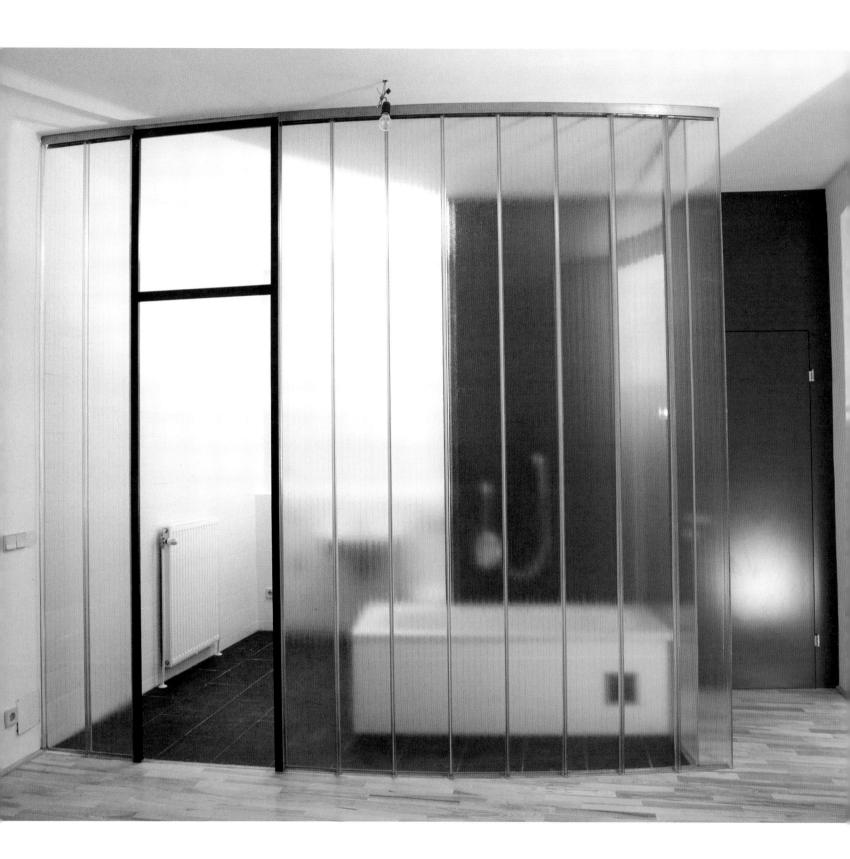

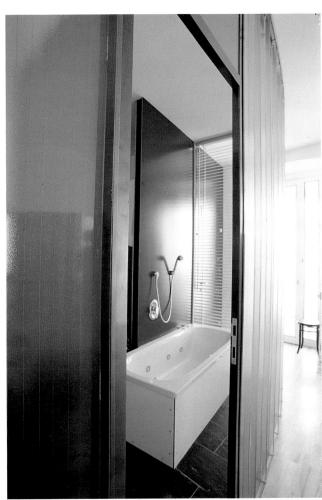

Migraco Torrigocui, maraj

Some of the partitions are translucent, in order to allow natural light to penetrate.

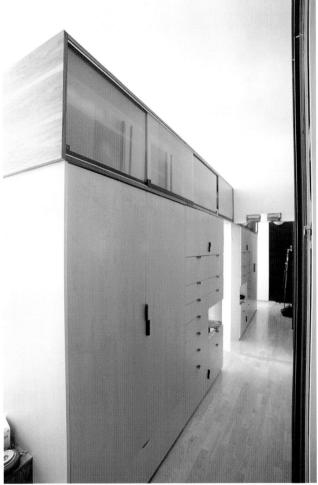

The furniture is the product of an exclusive design that combines wood, glass and aluminum.

The house stands on a large site that slopes sharply down toward the street, from which it is separated by a sturdy existing wall of local volcanic stone. The house is arranged around a large central patio, the element that governs its composition as a whole.

Vehicle access is gained by means of a turning place that serves three further houses that together form a larger complex. This condition determined the position of an open garage and the services zone. From the longest edge of the site, parallel to the street and to the volcanic stone wall, a stone stair leads to the main entrance, framed by a strong steel girder contained between the wall and the solid services volume, also of stone.

The access foyer is separated from the living area by a large fireplace. From here the house interior opens with a view in diagonal of the patio, which is framed by large oxidized steel porticoes. The pilasters are sturdy triangular prisms, the edges of which point towards this open space. Some of them are submerged in the waters of a large pond that flow gently through the patio, cutting it on a diagonal.

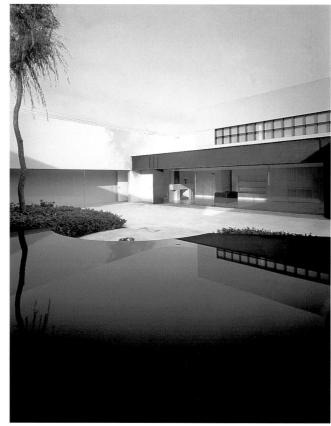

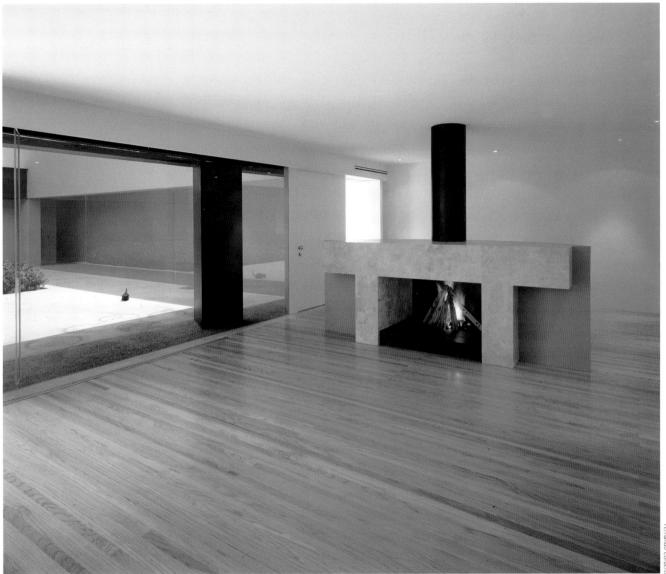

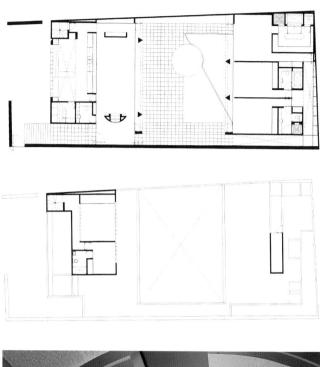

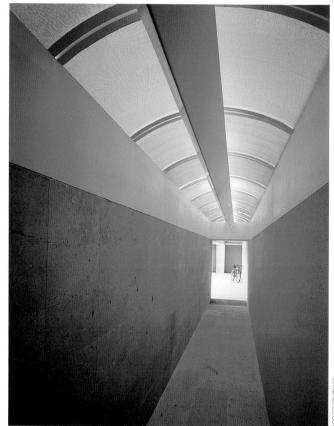

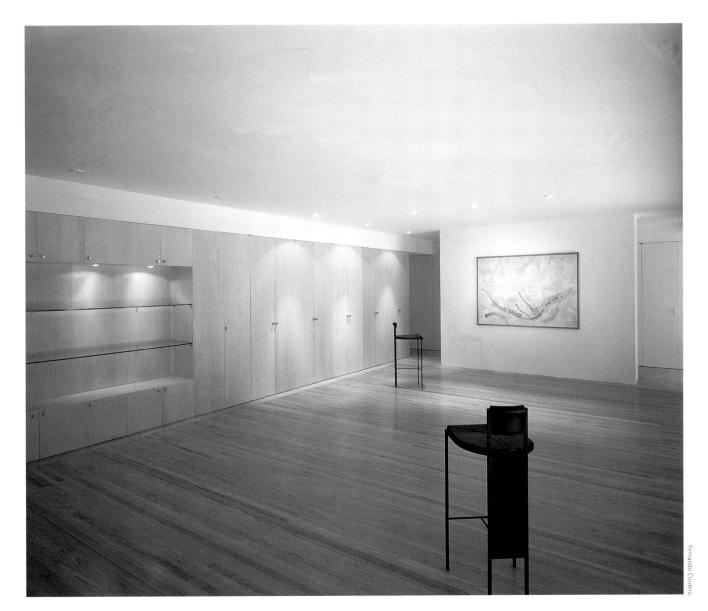

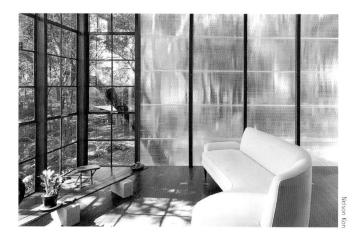

This house consists of two interconnected volumes the structure and materials of which clearly contrast with each other. These two volumes (a main space and a services space) are arranged along a longitudinal axis and take advantage of the shade provided by the trees.

The main body is a foyer of 31 x 13 feet consisting of a light jatobá timber framework structure surrounded by panels of alveolar polycarbonate. This translucent membrane gives way at one of its corners to the transparency of glass, thus framing the view over a nearby lake. A curtain that occasionally defines a dark, more private environment establishes the limits of the bedroom area. The regular layout of the underground electrical installation completes the necessary infrastructure for this volume.

For both formal and constructional reasons, this "light box" stands above the ground on a support. The floating corrugated sheet-metal roof contributes to the effect of weightlessness.

The services volume is conceived as a rock that emerges from the ground in the form of wide ceramic walls, thus protecting the main pavilion from the rays of the afternoon sun. This volume contains the kitchen, washroom, bathroom and gas deposits. The benches in the kitchen and the bathroom, the cupboards, and the shower partitions are either in masonry or concrete. The position and dimensions of the few openings respond strictly to their function, thus emphasizing a heavy, fixed character in counterpoint to the undifferentiated character of the translucent panels.

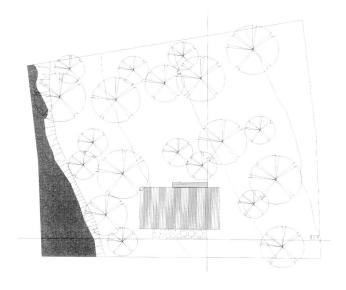

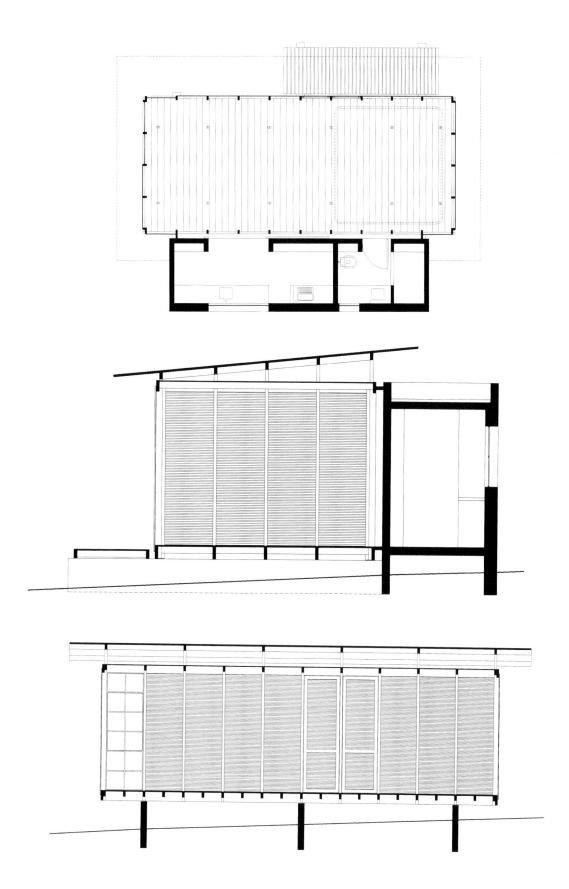

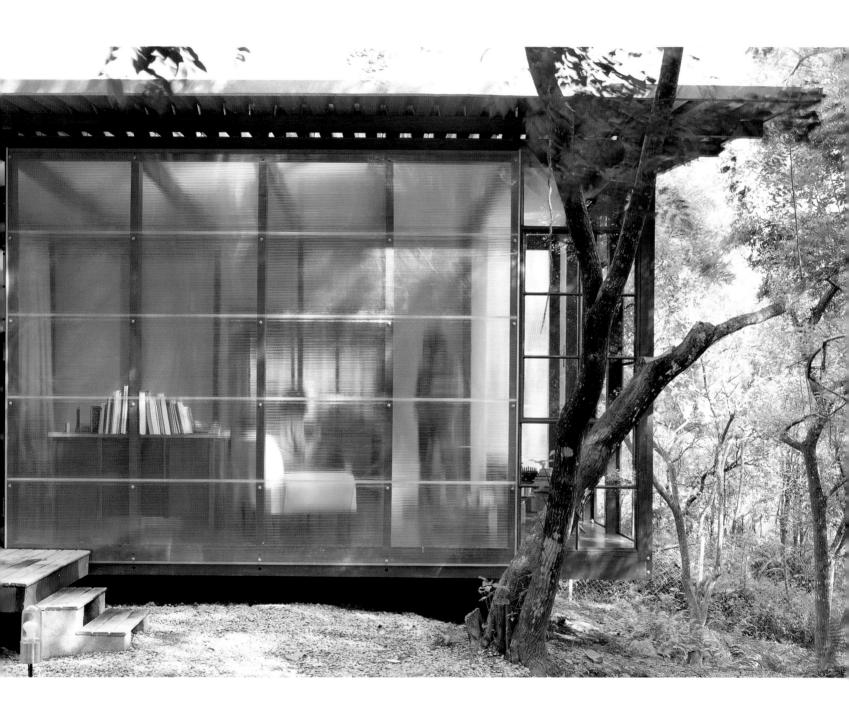

The different possible readings of this architectural object respond to the different degrees of transparency of its skin.

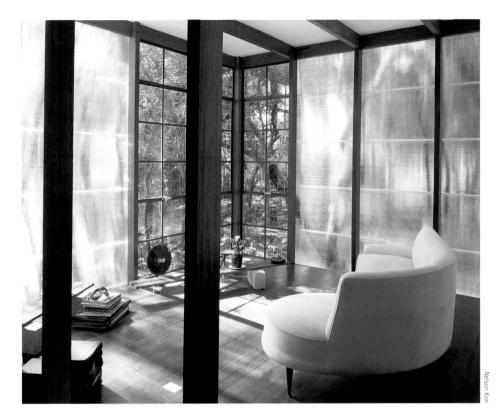

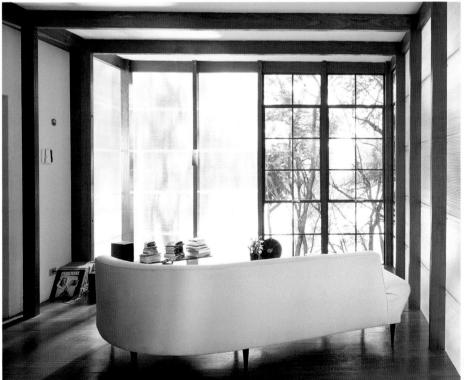

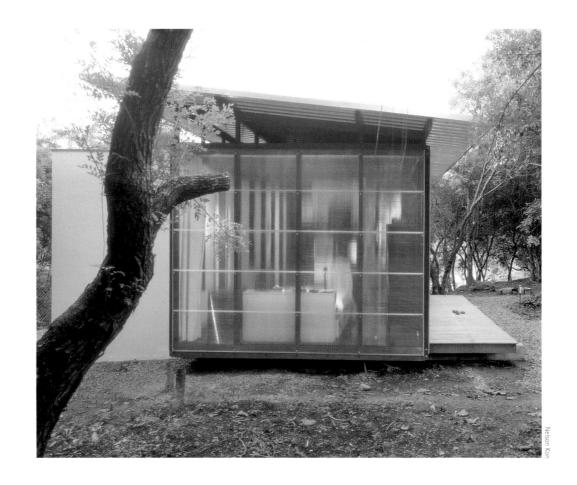

The distorted perception of the polycarbonate panels place the house somewhere between abstraction and reality itself.

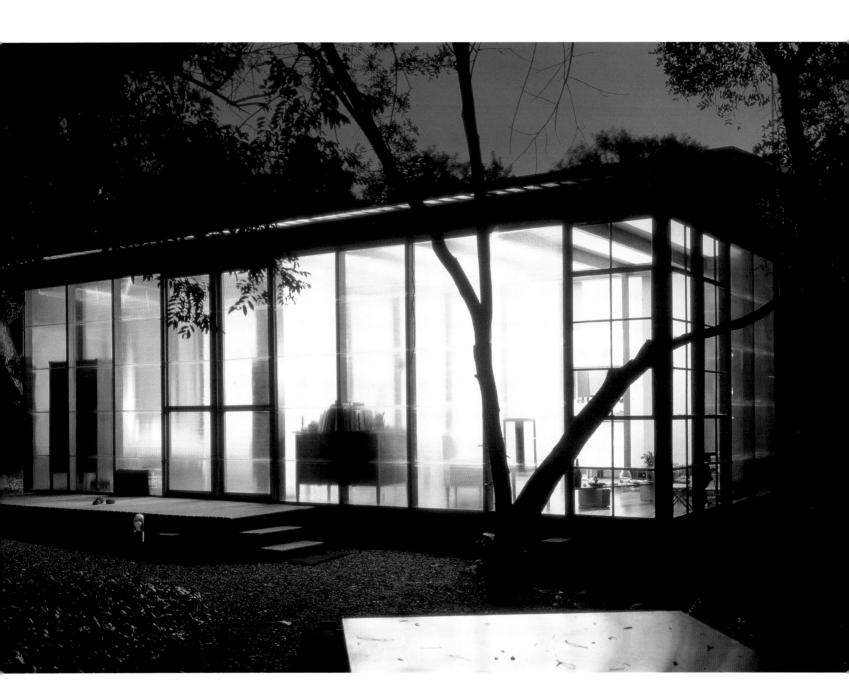

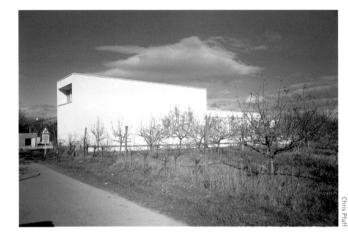

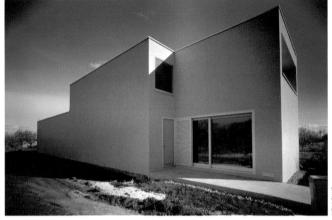

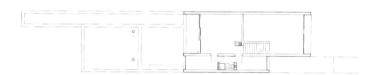

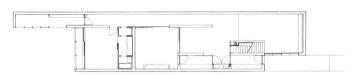

Permission was granted for the construction of the house provided it formed part of an overall plan for the entire zone, including a total of 150 dwellings arranged on long, narrow plots, in turn forming complexes on a larger scale. The dimensions of the plots made it necessary to construct semi-detached houses (of one or two stories) and find the means to allow natural light to penetrate the interiors.

The resultant form follows traditional building criteria with regard to the site, at the same time taking advantage of modern-day technology and materials.

The general plan for the zone contemplated the creation of a large natural space in the middle of the plots, which by virtue of their dimensions (25 feet wide by between 197 and 490 feet

long) were required to provide high density on relatively limited surface area. This was achieved through the use of the long patios characteristic of the area, mechanisms that make it possible to achieve simple linear subdivisions along the length of each plot.

Through the strict application of an existing typology, together with exploitation of advanced technology, an architecture was generated on the basis of semi-detached buildings of considerable length, thus forming a systematic series of differentiated units that may be extended according to the preferences and needs of each house owner. This idea is based on a specific dramaturgy that joins two poles: those of close traditional construction and of the distant ideal site.

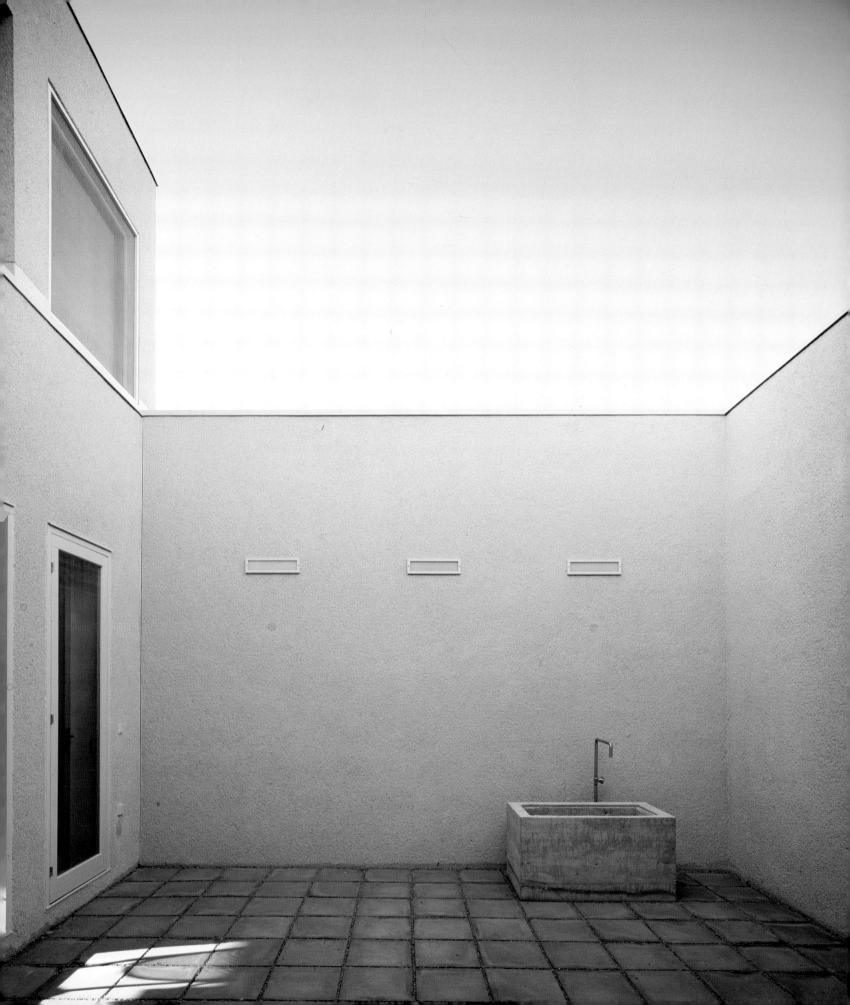

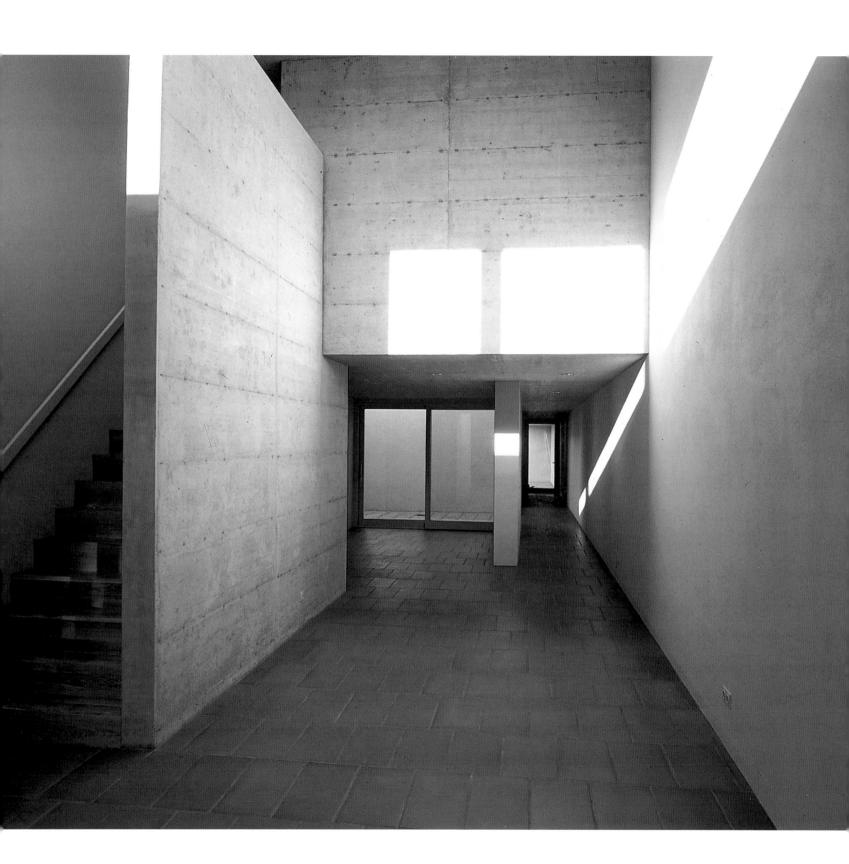

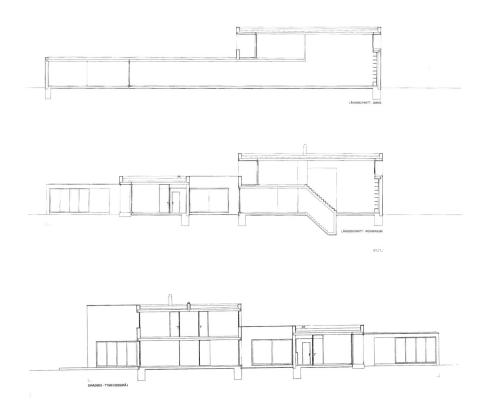

The architecture of this dwelling consists of an interplay between two-directional planes, some of which are structural, while others have a purely distributive function.

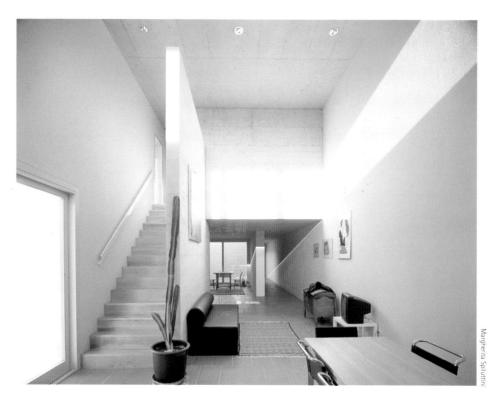

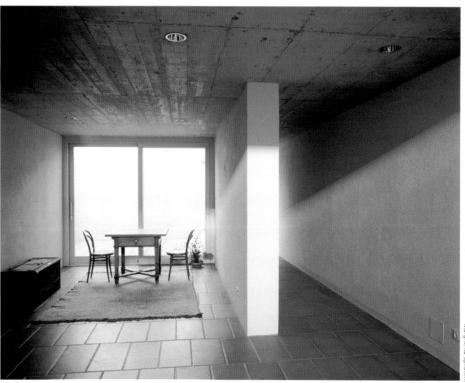

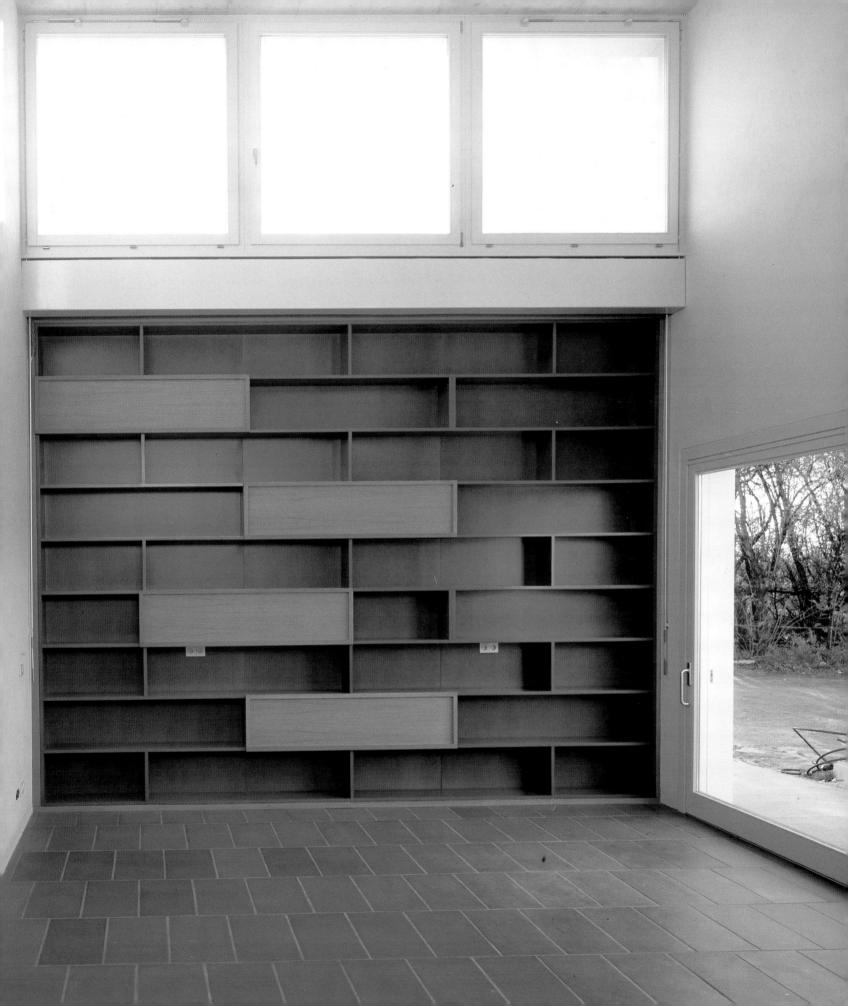

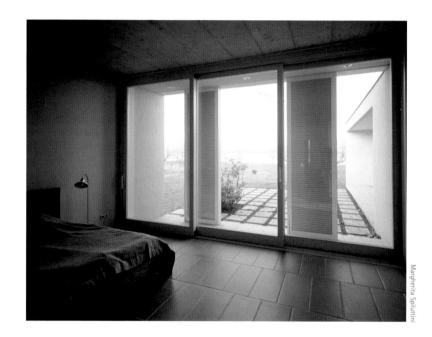

Given the length of the plot and the narrowness of the facades, considerable effort was devoted to designing the means to allow natural light to penetrate.

Concrete is a major presence, both on ceilings and on walls. The joins of the plank moulding have been preserved.

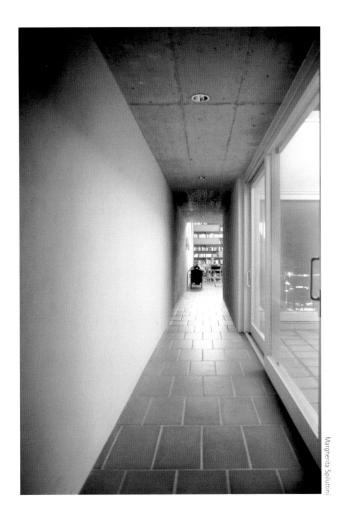

The alterations consist basically of the extension of an original volume at ground level, which groups together the main entrance, the toilets, an office, a salon and a living room.

All the floors of the old house will be altered: the existing basement, to which access is difficult, will be converted into a storehouse and bathroom; the kitchen and dining room will be on the ground floor; the two bedrooms at present on the second floor will be preserved; and the attic will accommodate a study and an installations room. On the other hand, new windows will

be opened in some of the rooms. The garden will be transformed into a continuation of the house interior.

The materials used for the extension consist of a cladding for the interior vertical faces of the same color as the existing house. The facade overlooking the garden will be glazed and framed by dark metal profiles. The exterior perimeter walls will be faced in gray-beige material that will be extended into the house interior. Both the chimney and the roof will be of zinc.

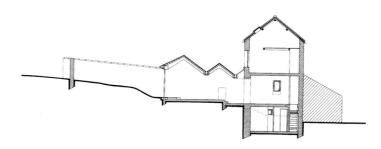

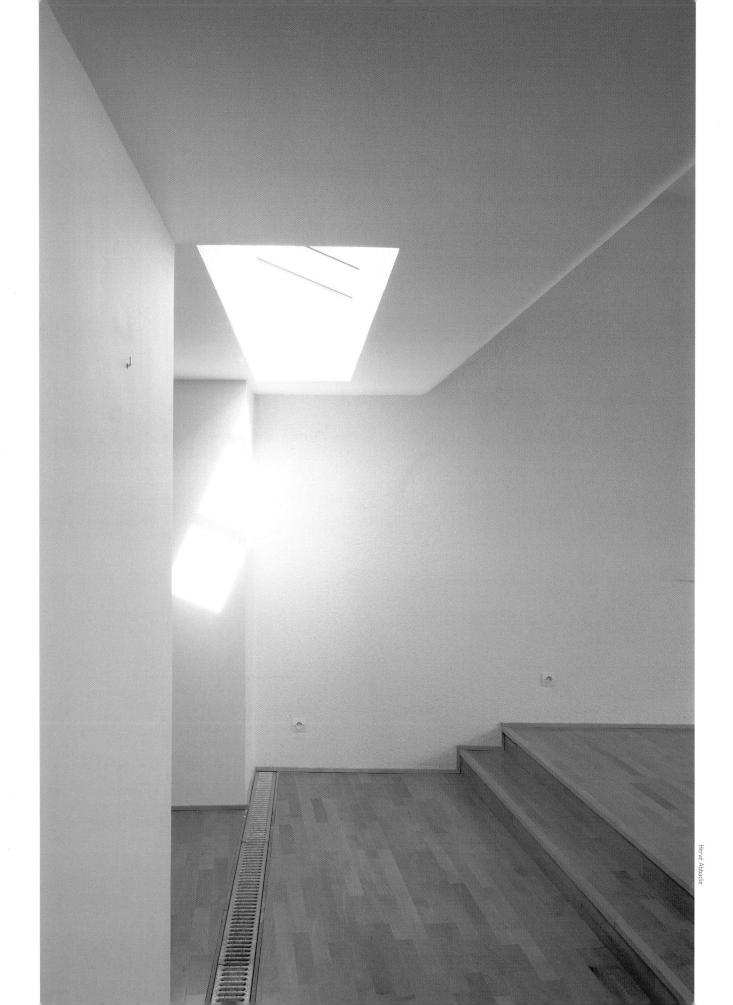

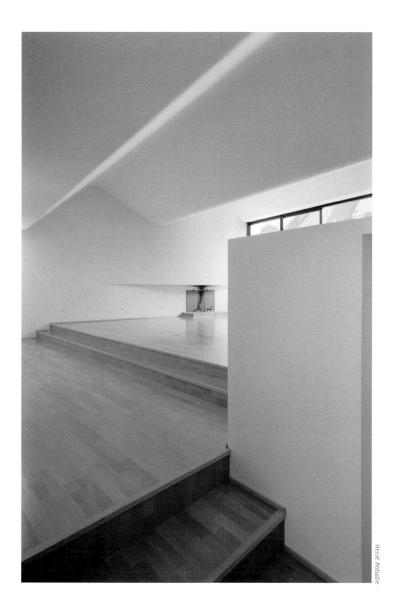

The waving ceiling creates different visual effects depending on the light that penetrates the interior.

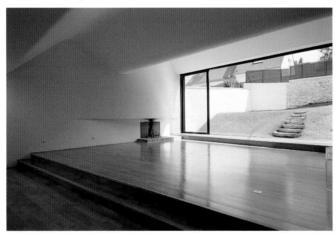

Hervé Abba

The glazed facade establishes a link between the interior and the garden.

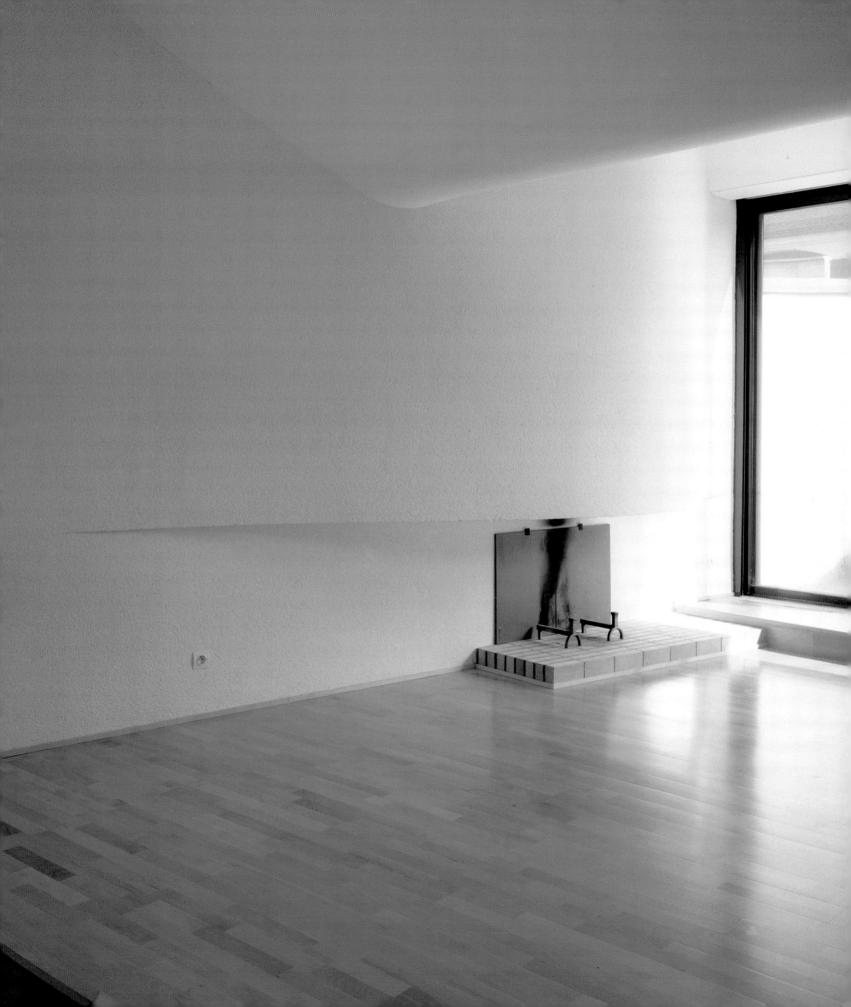

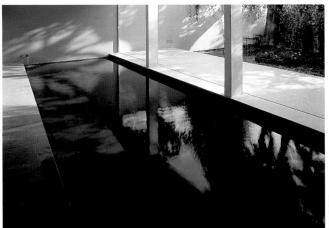

This projects consists of the remodelling of a three-story house built in Kensington in 1967 by architect James Melvin. The intervention consists of a 32 x 32-foot concrete cube, an innovative spatial element that adds new vibrantly colored volumes to the original structure. Each floor presents a different ambience.

On the ground floor a large translucent glass pane separates the access area from the swimming pool, behind which there is a garden. The interior spaces are separated from the exterior only by sliding glass panels. The second floor is open-plan, with broad windows offering panoramic views on two of the sides. The top floor -the bedrooms and guest apartment- constitute a world of privacy, sensuality and luxury.

In order to preserve spatial flexibility, the different zones are defined by brightly colored furniture-objects in which to keep the utensils of everyday life. The dialogue between these colored forms and the ubiquitous presence of the garden constitutes a dense, . urban combination of nature and architecture.

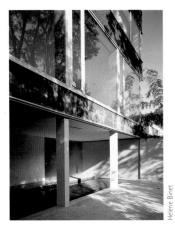

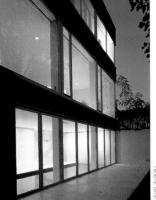

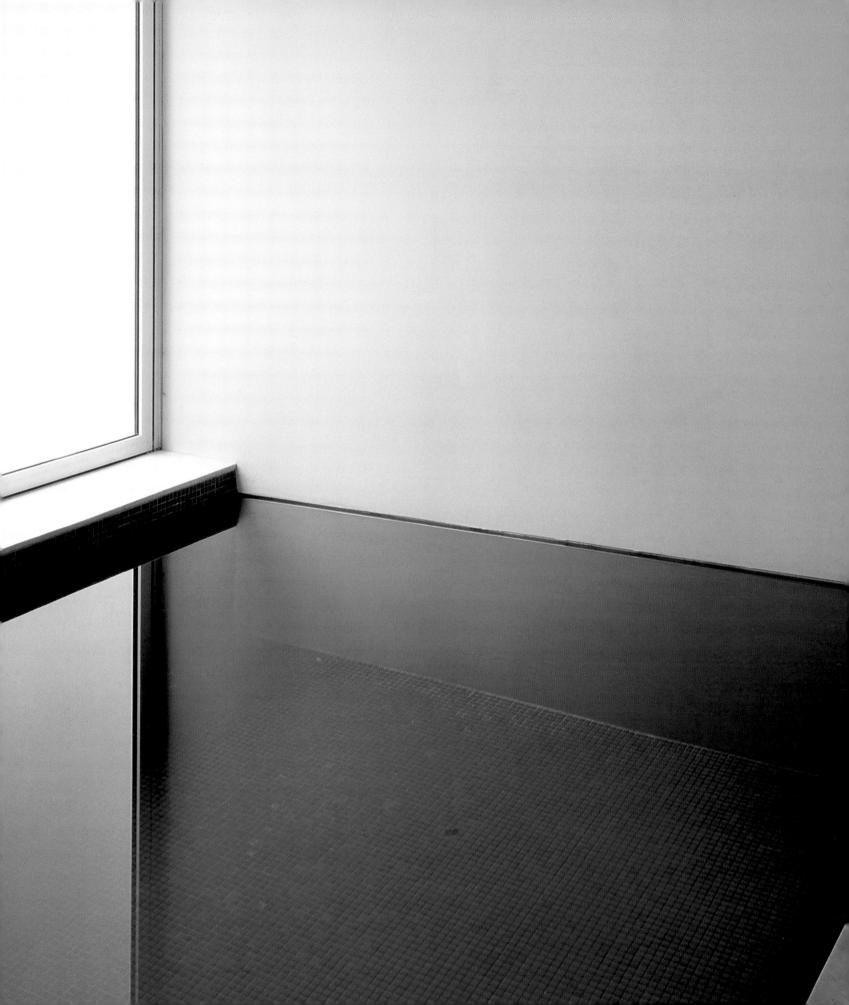

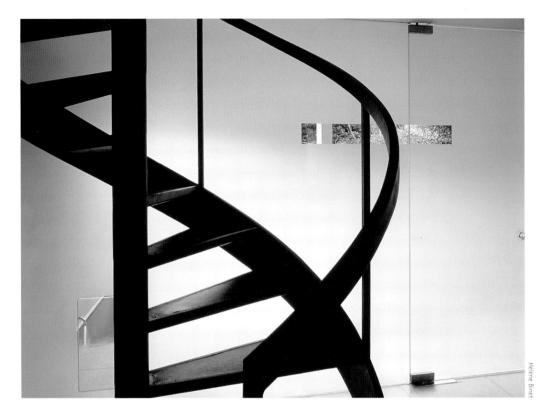

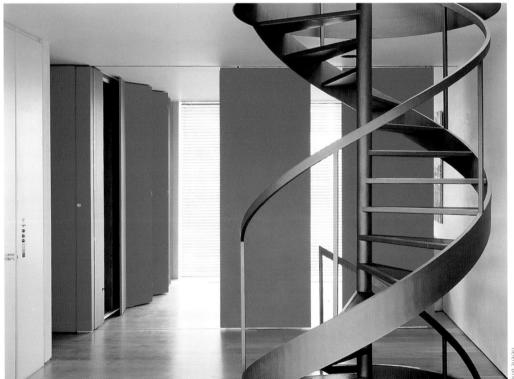

mnm

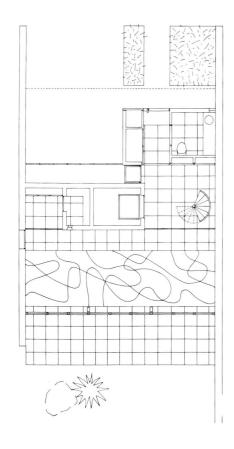

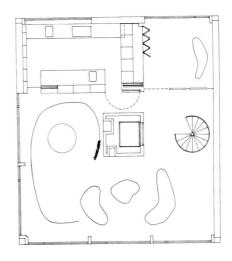

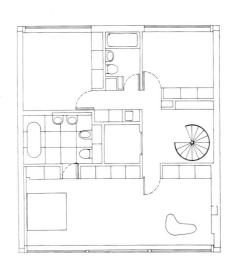

Ground floor.

First floor.

Second floor.

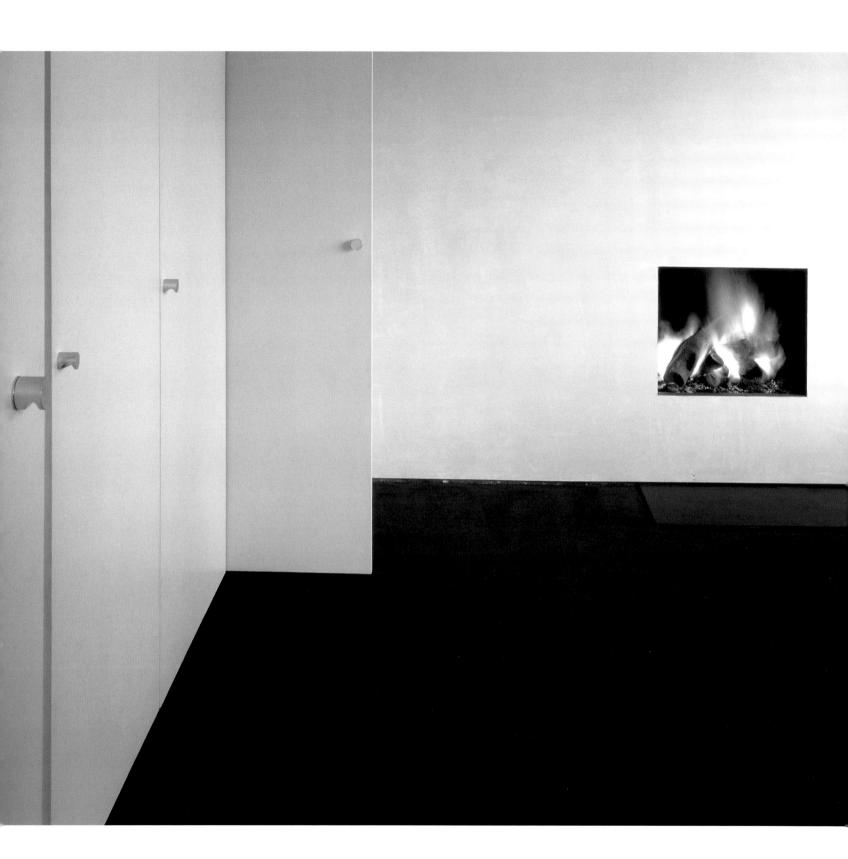

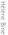

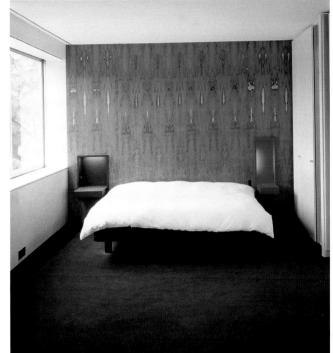

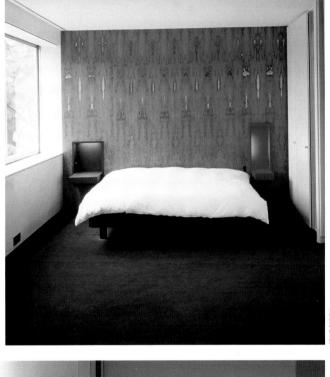

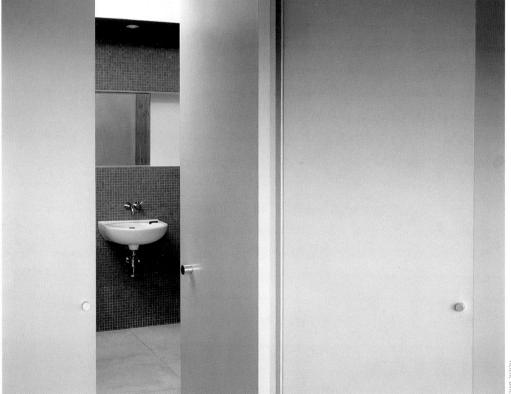

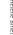

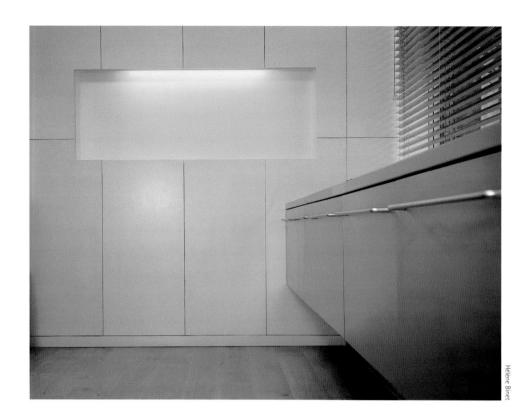

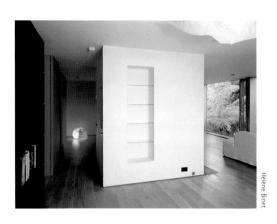

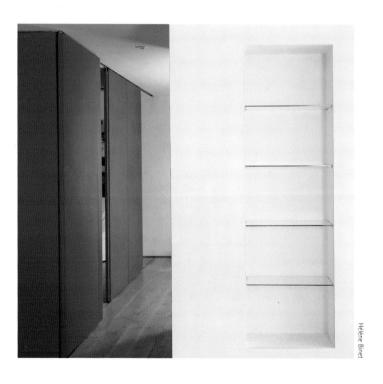

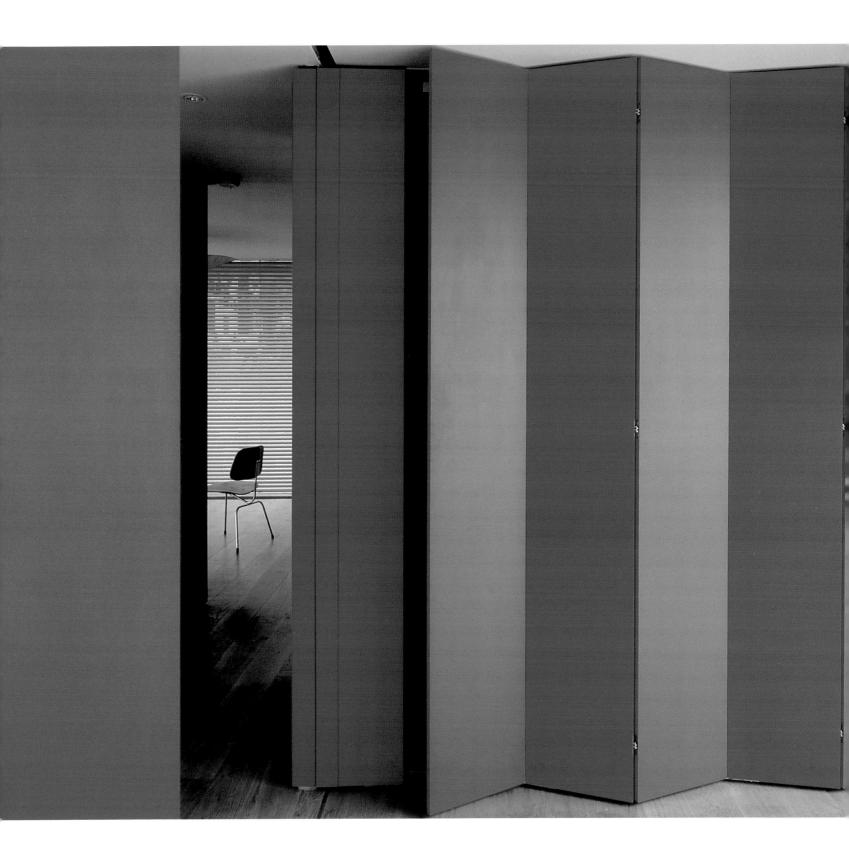

The brief consisted in remodelling a old two-story house standing on a site 25 feet wide by 246 long.

The alterations took the form of large open spaces, two bedrooms, a study and a swimming pool looking north at the rear of the house

The width of the site allowed the architect considerable flexibility when it came to designing the services area, which lies on one of the sides, leaving room for open, light-flooded spaces.

The ground floor is divided by a plywood structure that separates the living-dining room from the services spaces.

These spaces open onto the patio at the rear of the house, with a swimming pool along one of its sides. The threshold connecting the kitchen and the patio may be converted, when required, into an informal dining area.

On the first floor the same strategy was applied of subdividing space through the use of a wooden furniture structure placed lengthwise, parallel to the stairs. It serves as a cupboard for both bedrooms, and also for the changing room. The bathroom is oriented frontally toward the swimming pool. The second-floor study opens onto a terrace with excellent views of the city and Harbour Bridge.

Ground floor.

First floor.

Second floor.

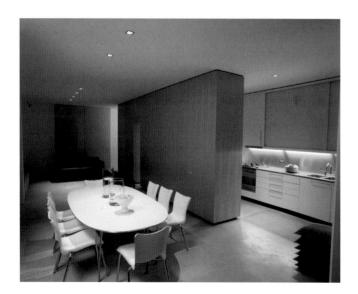

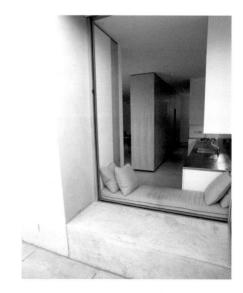

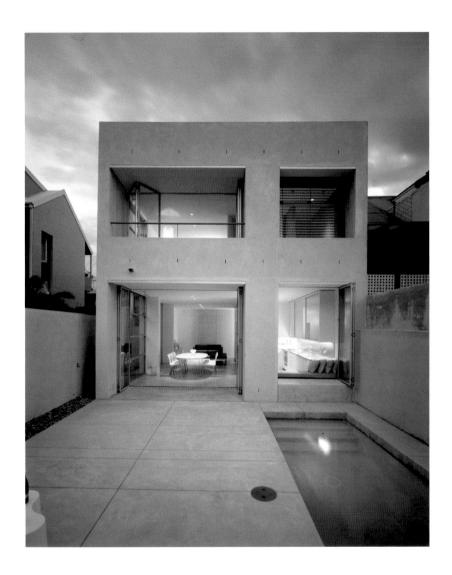

The architecture is in general simple, and it makes use of few materials.

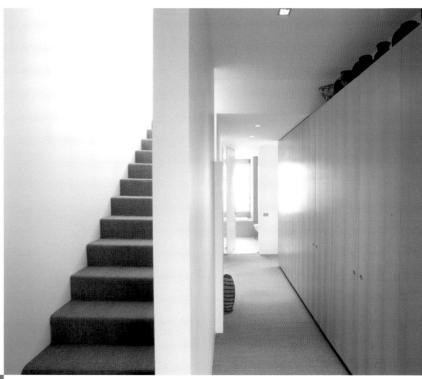

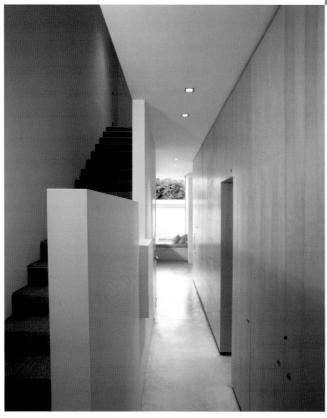

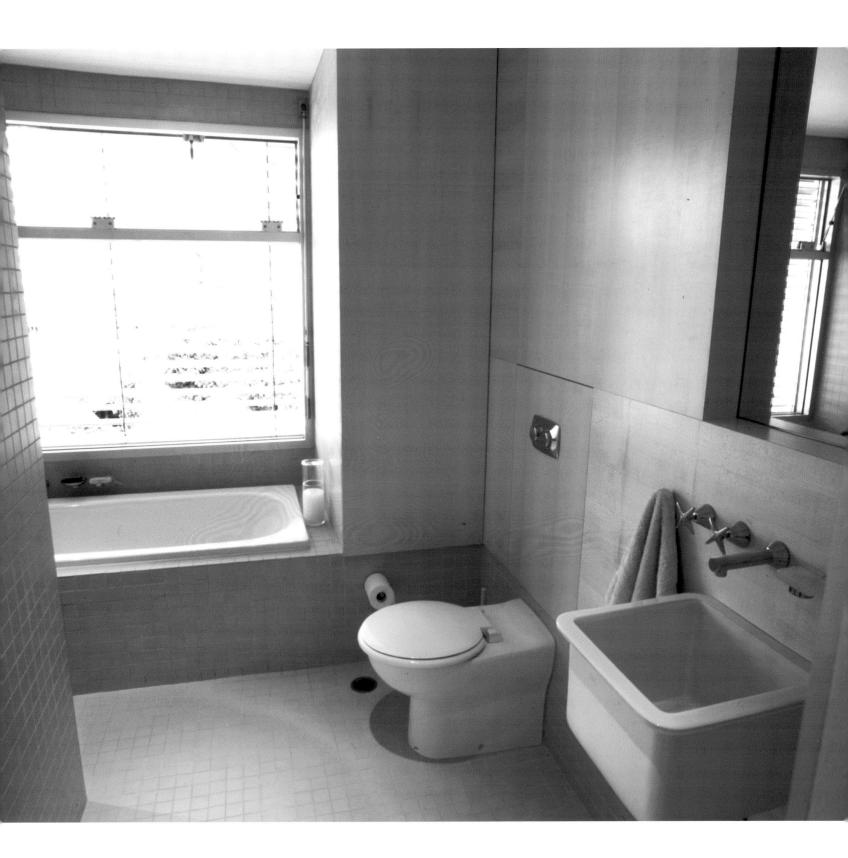

This pavilion forms part of a series of experimental projects that the architect calls "Case Study Houses". Built on a steep slope, and designed to minimize excavation work, the rear half of this house has been inserted into the earth. The ground curves at one end to meet the roof slab, which rests only on three very slender cylindrical pillars. The fundamental idea behind this house is to establish spatial continuity both inside and outside. Two planes, defined by the floor and the roof, create and frame a horizon. Limits have been eliminated: the inner space has no partitions and visibility is total even in such private places as the bathroom, which is crudely exposed to view. Only the kitchen unit, a bench, and a few pieces of furniture suggest light zone differentiation in what is essentially a single, homogeneous space.

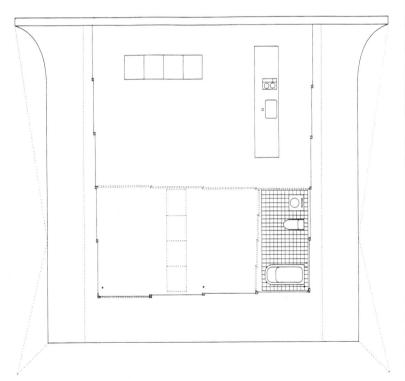

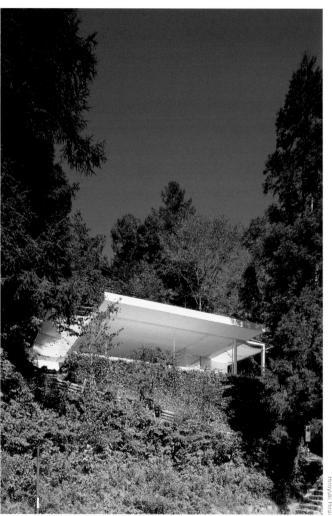

The interior is transformed by means of sliding panels, which multiply possibilities of use as well as endowing each room with a new character. The curvilinear forms are of extreme simplicity, the structure almost disappears, and the total transparency of exterior limits creates the impression that the house is contained in the landscape.

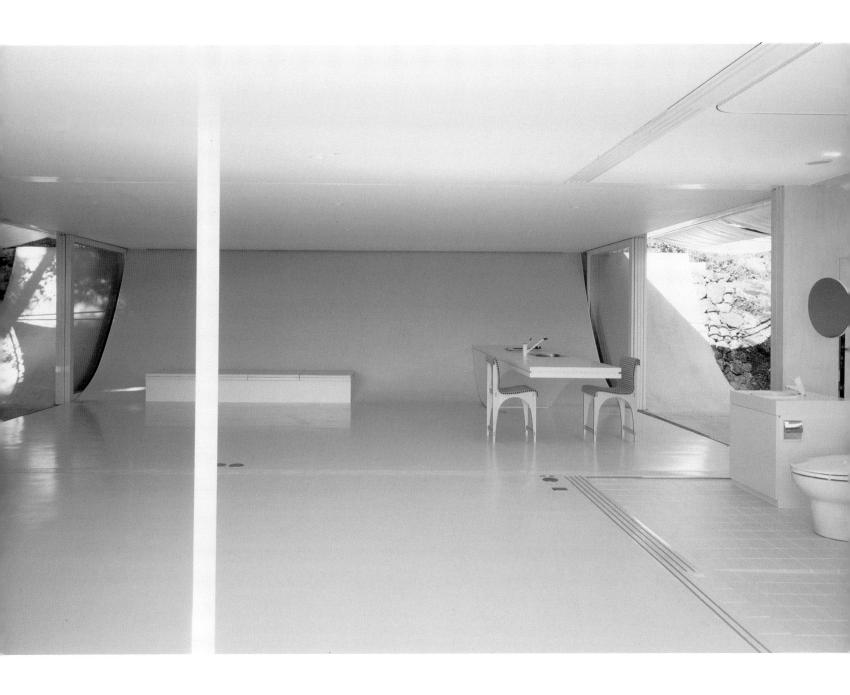

Although the concepts that govern the project are at odds with functionality, they are theoretical achievements that serve as examples for other architects.

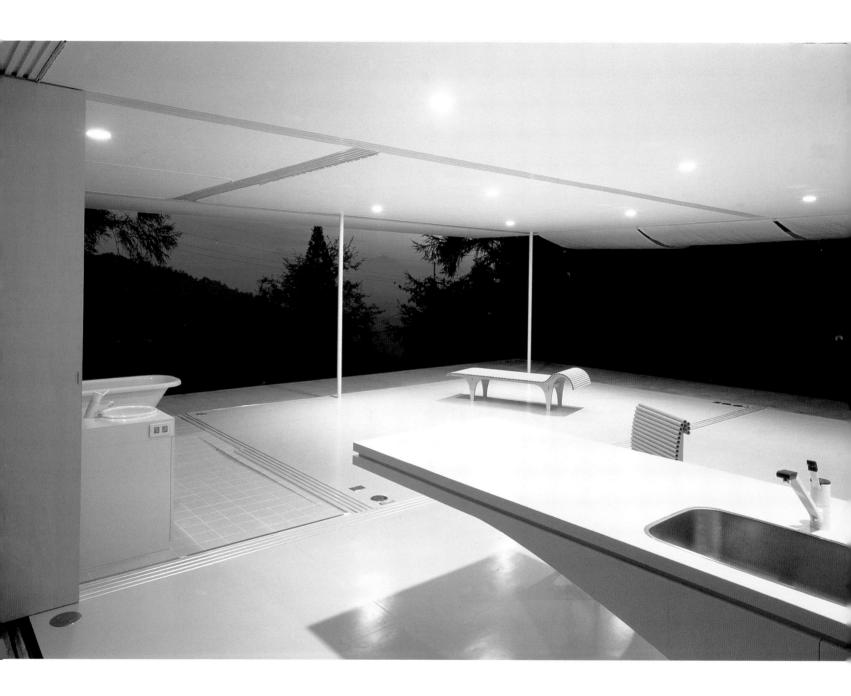

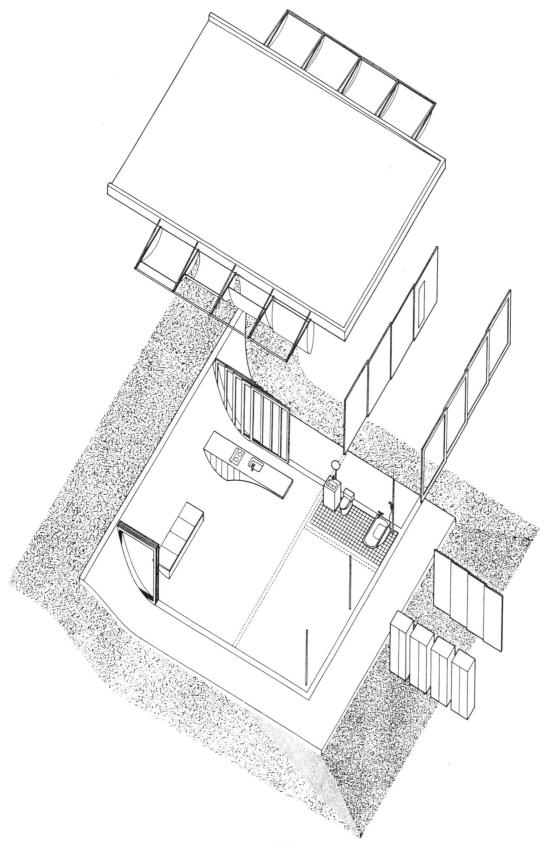

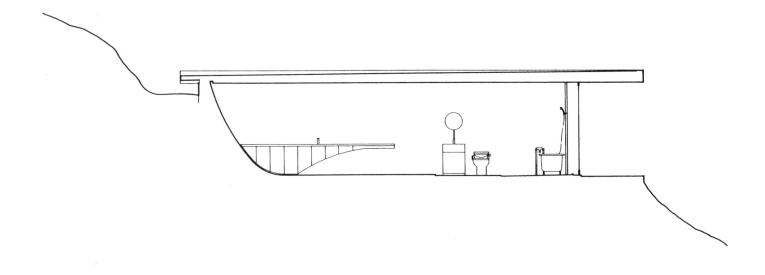

The section clearly reveals the architect's determination not to intervene in the land. Alterations are minimal, and the house rests on the site.

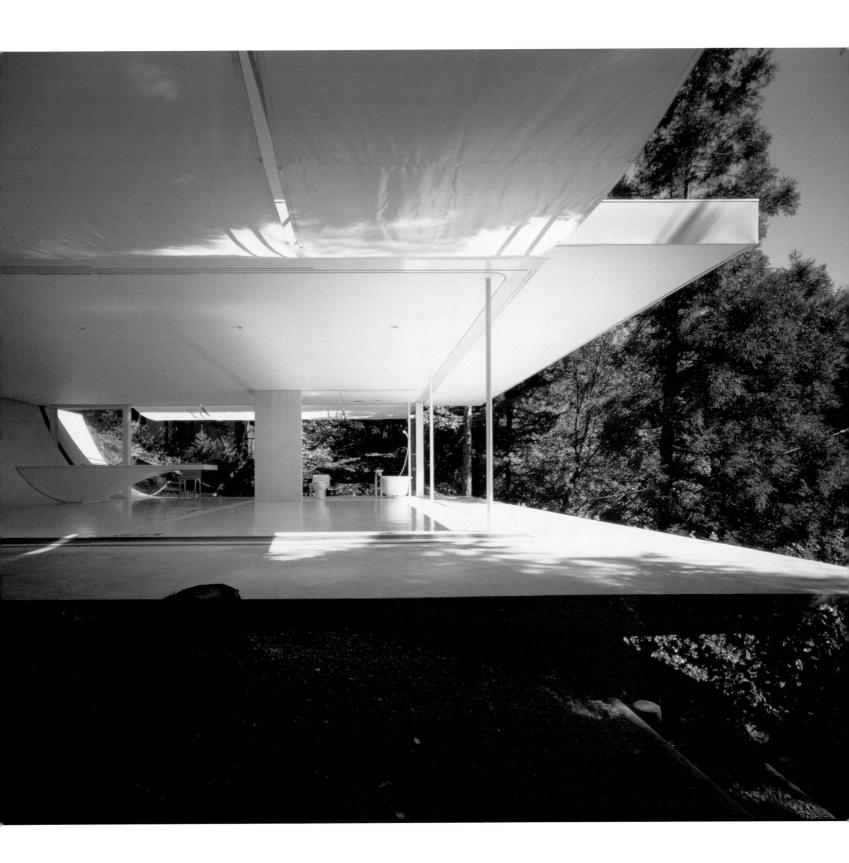

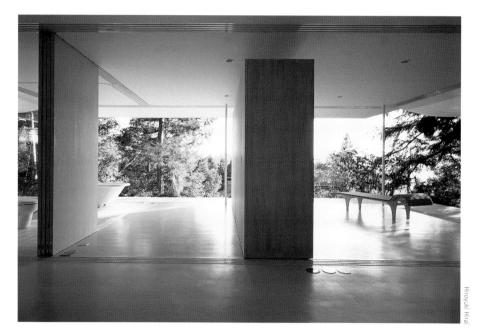

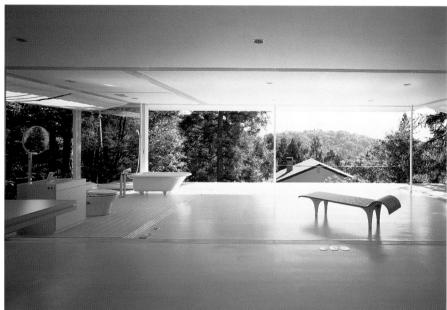

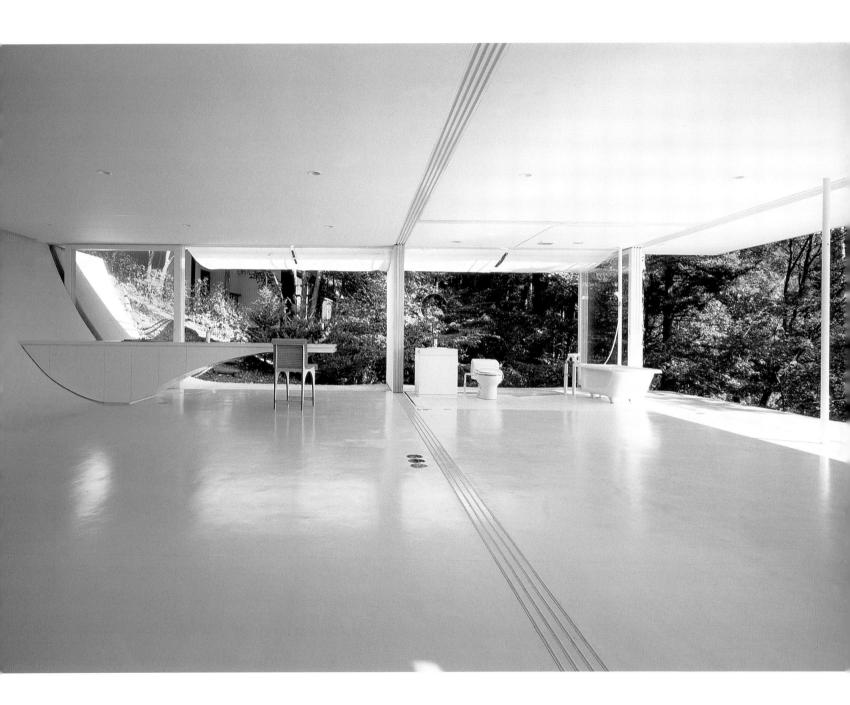

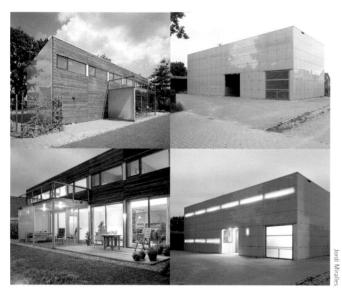

This house is an austere container whose dimensions are based on the repetition of a module the size of a single bedroom. Toward the street and on the side facades, a serigraphed glass plate clads the whole volume like a kind of exterior ventilated leaf, overlooking the presence of windows and forming a taut skin broken only by the access porch and by the garage door. This smooth surface functions as a huge screen that during the day reflects the entire exterior. In contrast, at night it reveals tiny episodes of the inner life of the house.

This box, cold and closed on the street side, opens onto the garden through a glass volume of exquisite purity. Large windows generate a direct relationship between interior and exterior. The rest of the facade is covered by horizontal wooden slats, also arranged as a ventilated front. The finish material inside is birch wood, which provides a warm, pleasant atmosphere.

The refined construction and rigorous modulation together complete a minimalist project based on very few formulations that assumes a clearly objectual role, characteristic of architecture far removed from the nature of the site.

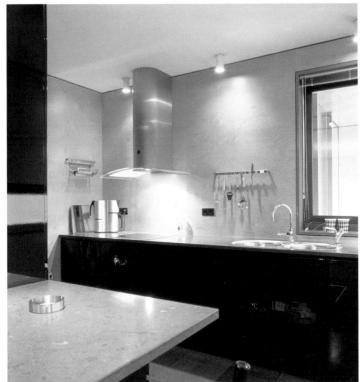

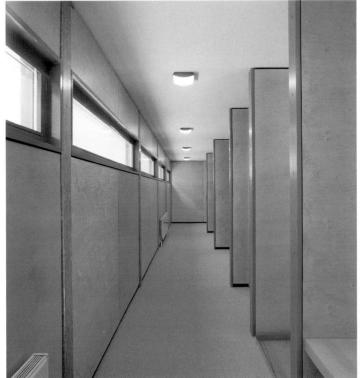

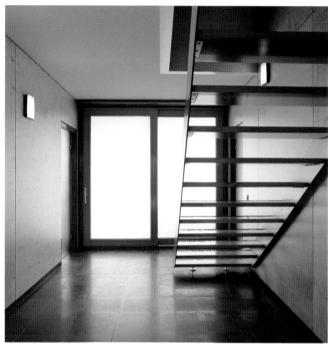

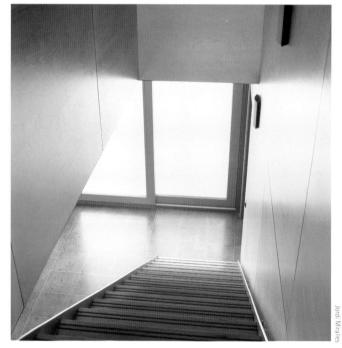

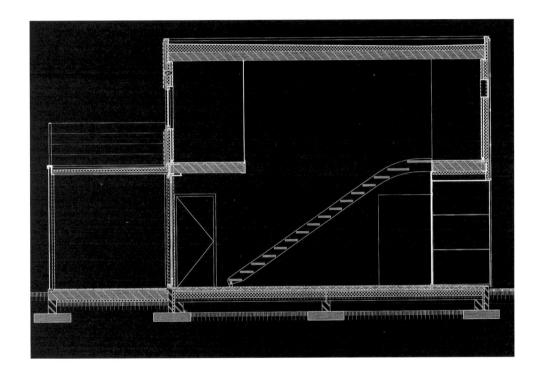

The structure is determined by the repetition of a module the size of a single bedroom. This compositional rhythm also provides the pattern for the windows.

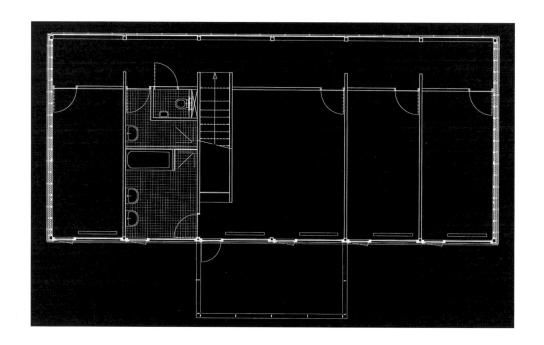

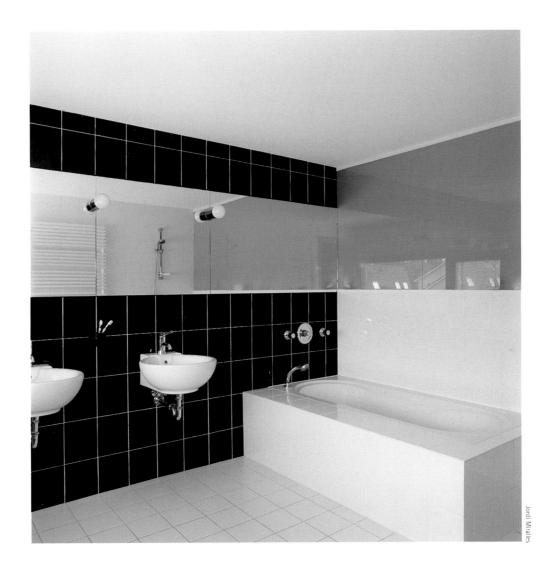

The project was devised to endow the house with its essential character through a minimum number of elements.

Conceived to be surrounded by gardens, this house stands beside a glen in Palmira, Cuernavaca. As yet unfinished, since a garden takes a long time to grow, the house is like a seed left to germinate in the earth.

This pavilion surrounded by greenery was conceived, above all for functional reasons, as a compact whole that nonetheless extends all over the site. Each rooms frames a different garden. The complex is based on four long walls and two concrete towers. Access is gained by means of a sloping plaza paved with local stone that passes beneath a shelter that will eventually be covered by a bougainvillaea, and leads to the small vestibule. The living room is a deep terrace open to the north-west garden, surrounded by acacias and jasmines. The dining room is closed by long walls and adorned with abelias and nandinas in an orange-tree patio. The study shares a terrace with the swimming pool, while the bedrooms are submerged in a luxuriant garden.

In time the vegetation will gradually occupy the space assigned to it in the design. The mud walls, the concrete and the wood used for the plank moulds will eventually age and become incorporated into the garden.

Pep A

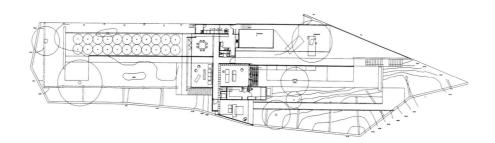

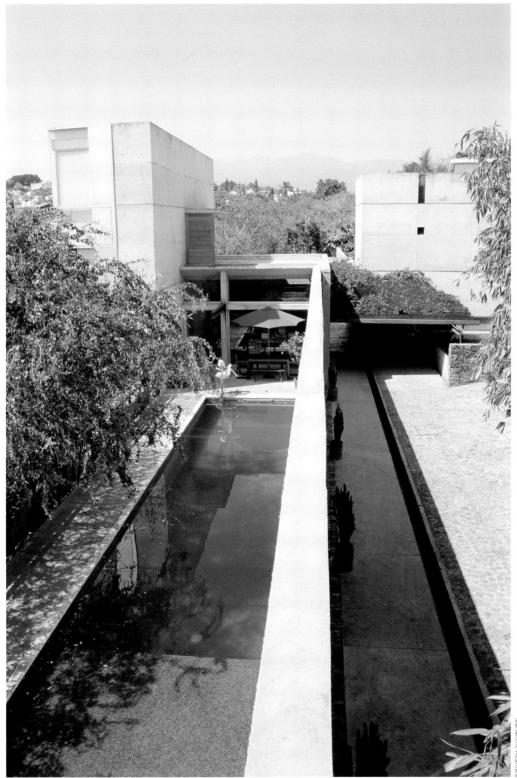

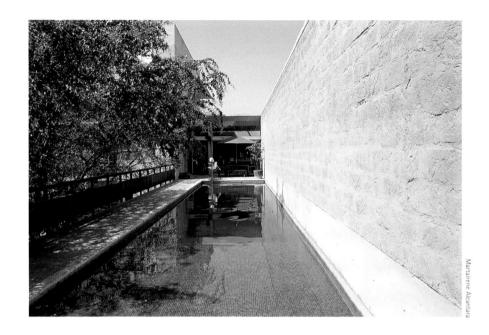

The house is conceived as a combination between interior and exterior spaces, the frontiers between which are blurred by the reflections and transparency of glass.

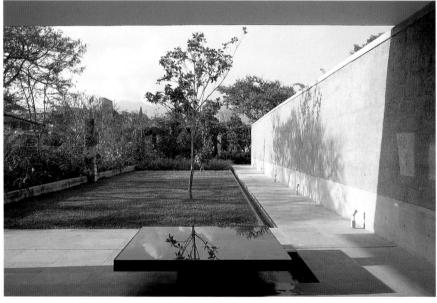

The sections clearly reveal the layout of the project: four long walls and two concrete towers. The arrangement of these elements determines all the spaces of the dwelling and the garden.

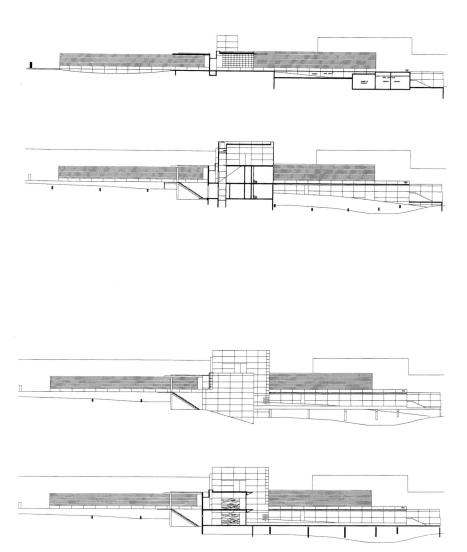

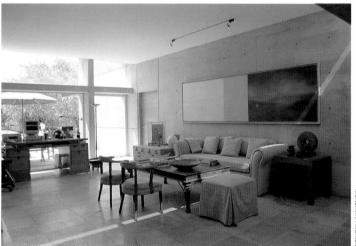

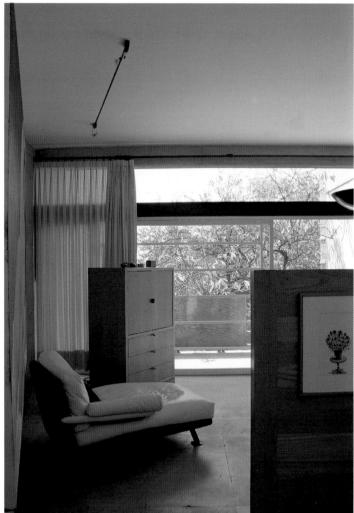

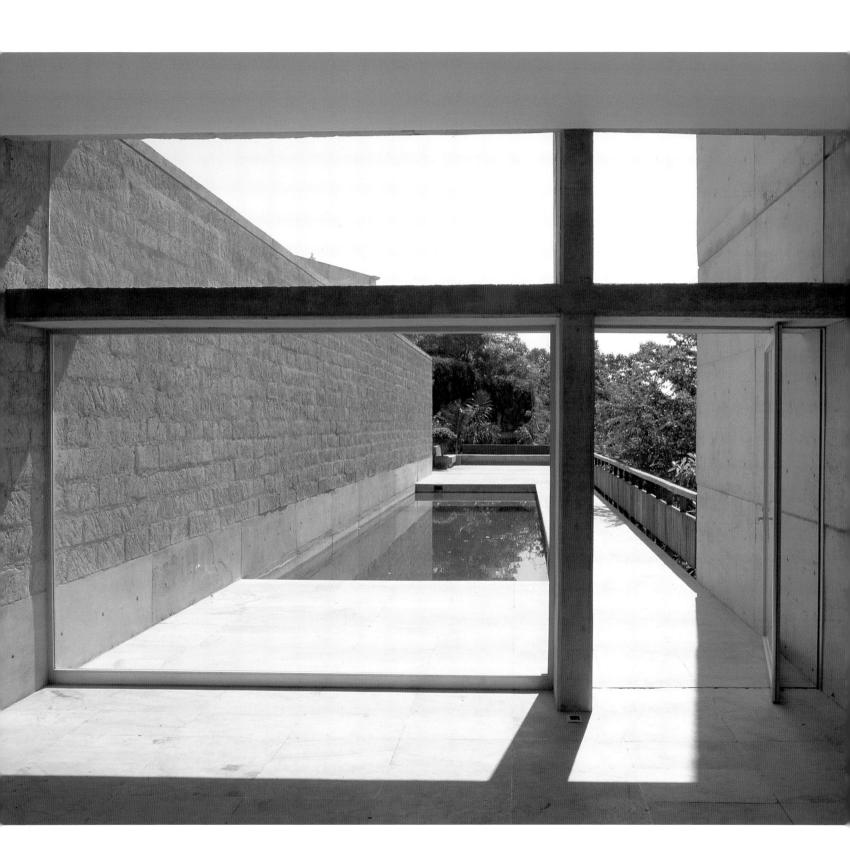

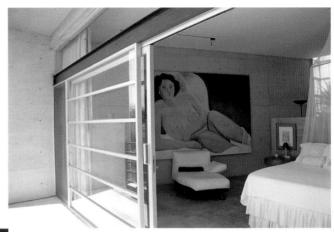

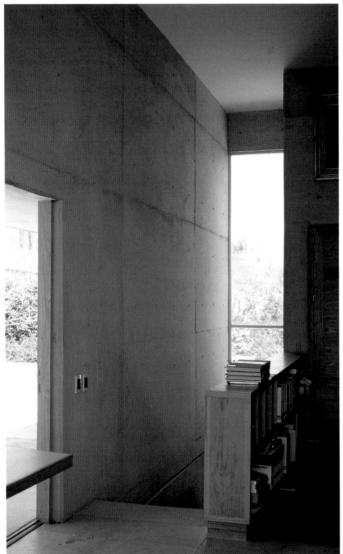

The concrete walls and the timber used for the plank moulds will age as the plants grow and gradually occupy their place.

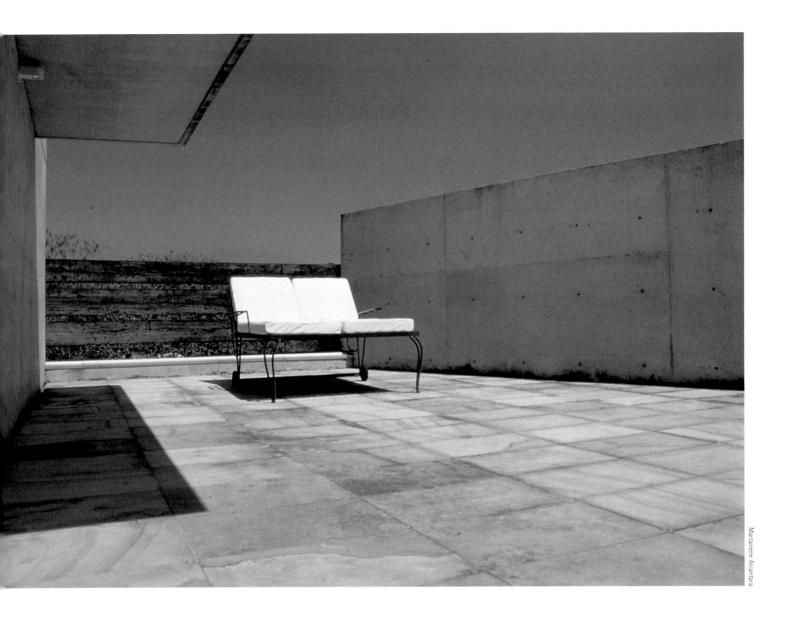

This medium-sized apartment is contained in a building with excellent sea views. The program is split into two levels, with different types of terraces at both ends.

The main idea was to group services (toilets, kitchen, cupboards, and so on) and the nucleus of vertical communication (access elevator and interior stairs) in the central zone. In this way, the need for vertical dividing elements was eliminated and, at the same time, the use maximized of the interior space thanks to circulations that run around the perimeter of the dwelling and enjoy light and views. This is particularly noticeable on the lower floor, where a pair of strategically placed sliding doors subdivide the space. On the floor above, the layout is the same, with the services in the central

nucleus. However, since this is the bedroom area, the space is fragmented in order to provide greater privacy.

Especially significant is the new geometry of the main floor perimeter: small, secluded rest areas have been created around the windows to offset the presence of the sloping roof inside the dwelling and the many insets of the perimeter wall. These private rooms may also be closed behind their respective sliding doors.

In terms of materials, the kitchen and bathrooms have traits in common: both the freestanding unit, consisting of sink and stove, and the bathtub, are treated as objects of clear, clean forms. The use of dark stone endows their material presence with a hard, solid appearance.

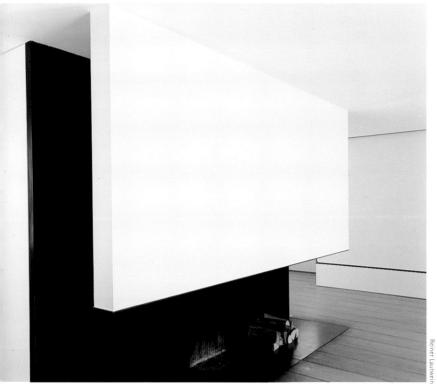

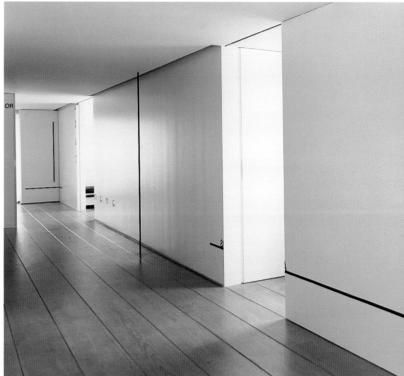

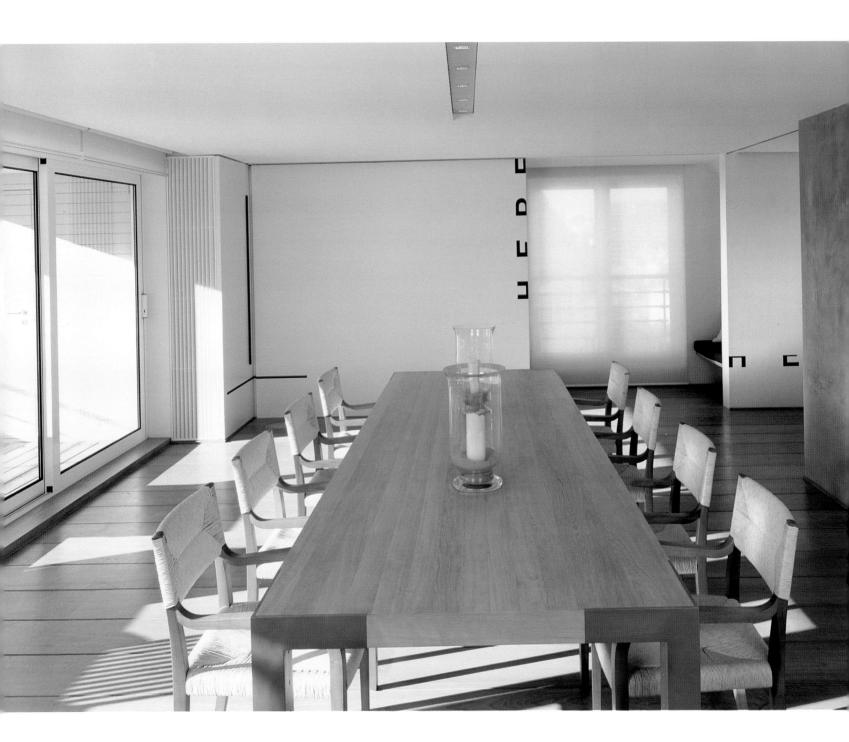

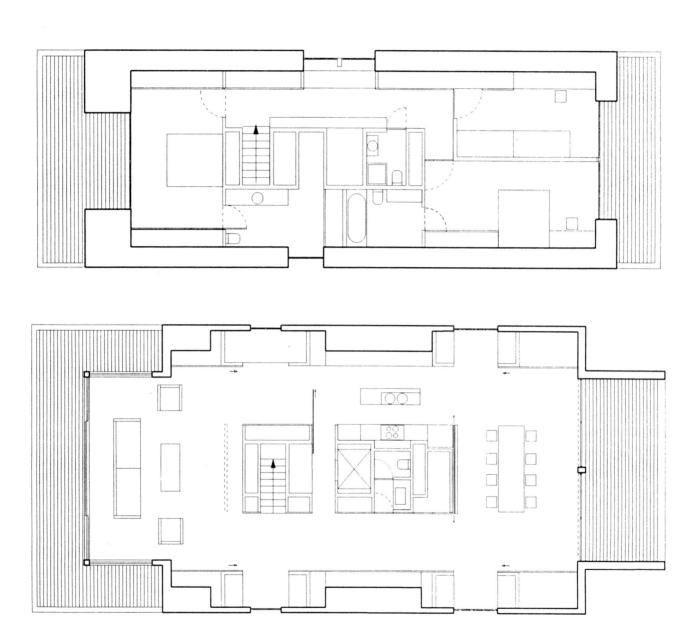

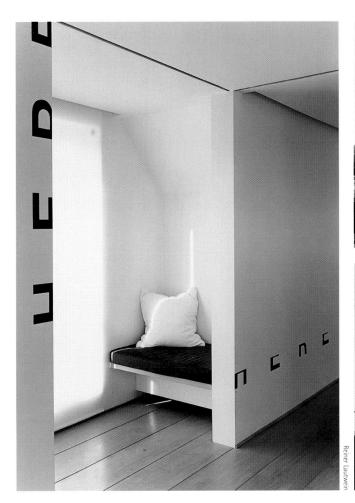

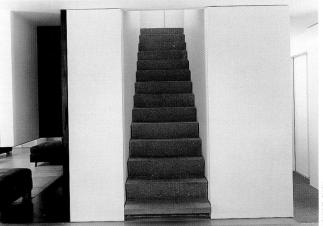

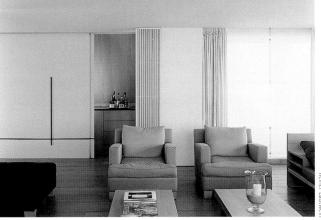

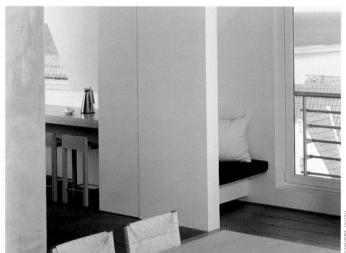

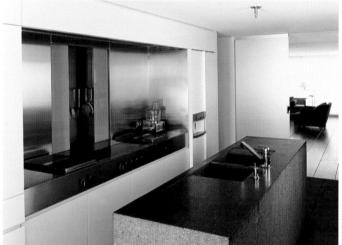

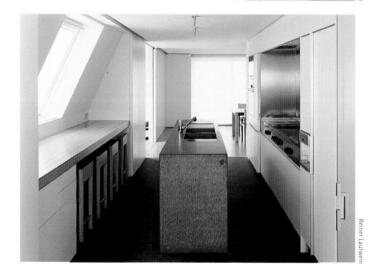

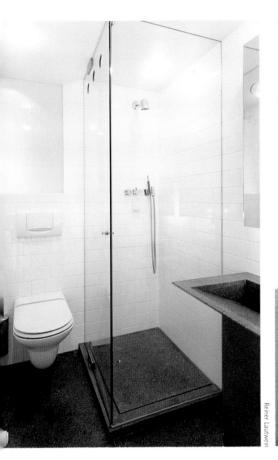

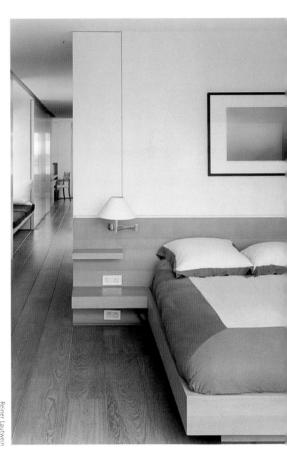

Resting on a small contained space, this building is a simple, single-floor rectangle with a basement in the middle. This space, the roof, and the side walls together define a rectangular framework which, like a large window looking toward the sea, contains the different rooms. Each room opens to the exterior through a system of wooden shutters that, when closed, are aligned with the exterior cladding of the same material.

Although the house is encased in this huge, simple framework, its interior spaces are complex, combining with and differing from each other depending on the play of light from above and on the different

heights of the ceilings. Some elements, such as the porch or the outer gate, are transparent, revealing what is on the other side. The spaces are lineally arranged along the length of the framework, leaving the toilet areas further inside.

The use of color, the movable rear facade, and the subtle interplay between the ground, basement, and main platform levels endow this apparently rigid and totalitarian regular body with greater flexibility.

The metaphor of the window is a figure that constantly pursues this building, perhaps by virtue of the force of this work, born from the absolute simplicity of its architecture.

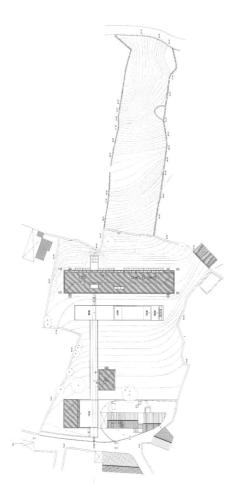

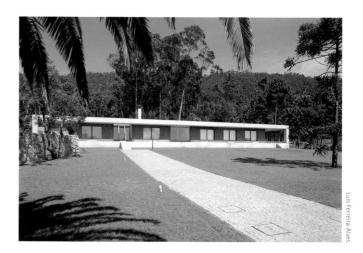

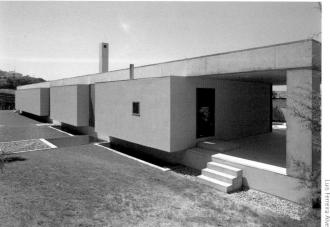

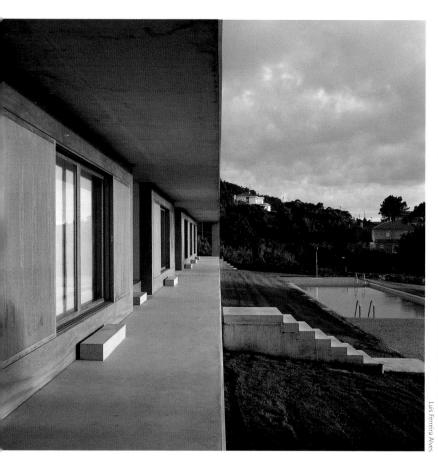

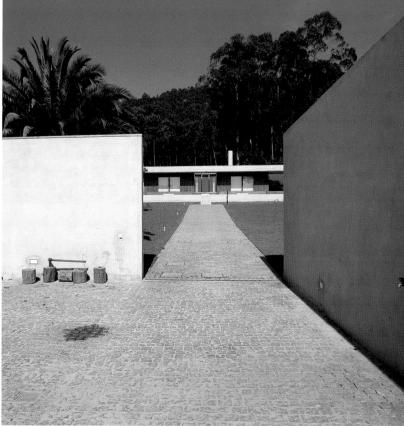

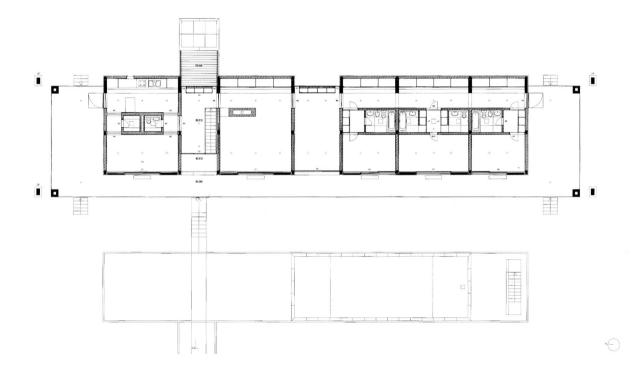

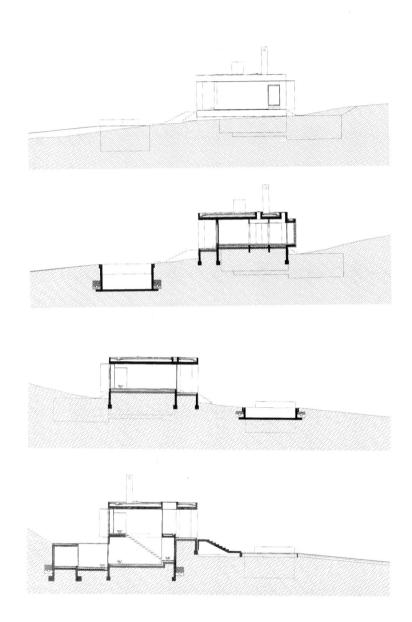

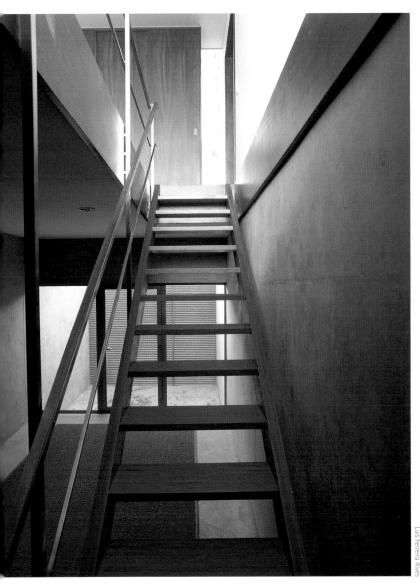

The interior is visually influenced by the facade openings, which create multiple interplays of light.

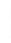

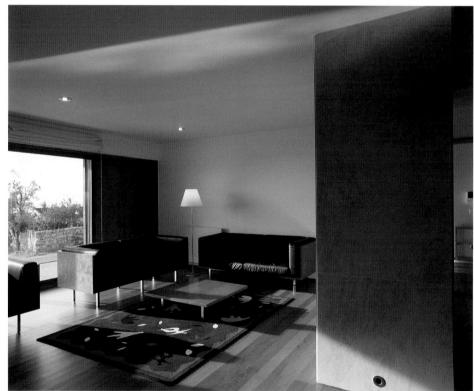

The finishes combine stone, timber flooring and partitions, and plastered walls and ceilings.

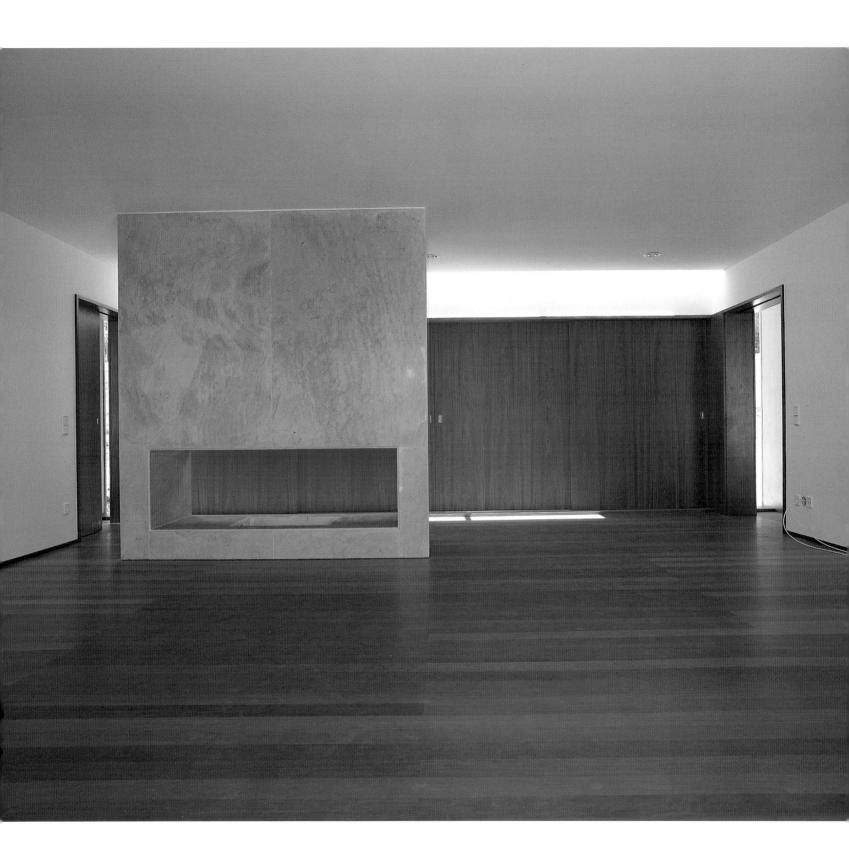

All evidence of mechanical accessories has been eliminated. The columns conceal the air-conditioning system behind subtle joins between panels. Ventilation is obtained through narrow zones that separate flat surfaces of different materials. A single panel hidden behind a shining wall coordinates all the control systems: temperature, lighting, security, audio/video, and communications.

A set of light oaken blinds opposite the top of the window is activated by remote control to reduce light penetration from outside. The original mullions of the window wall have been highlighted to obtain a grille of clear, precise profiles.

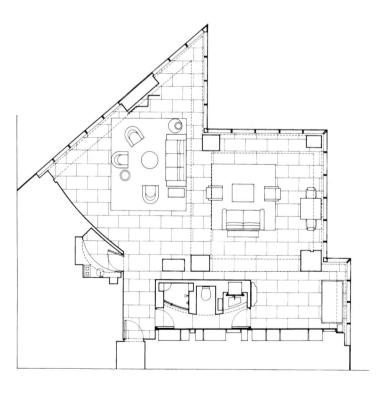

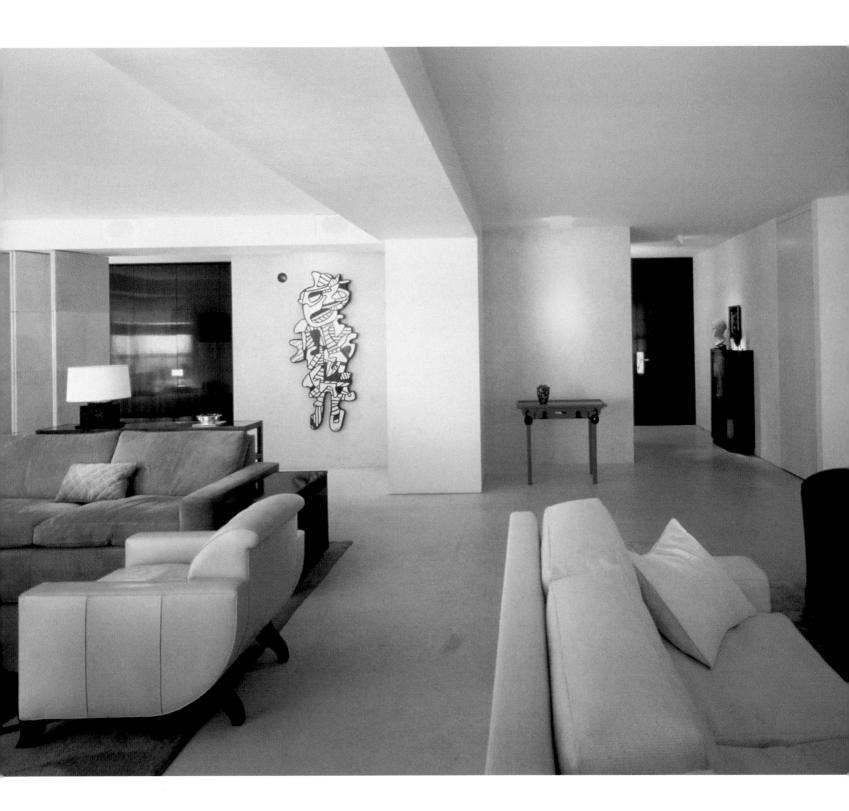

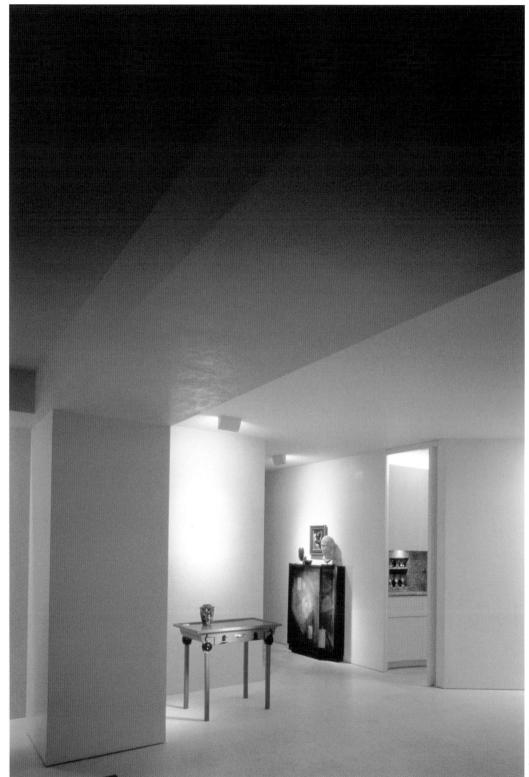

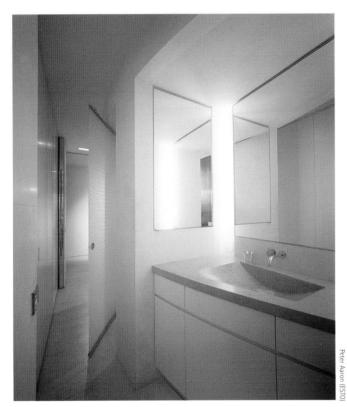

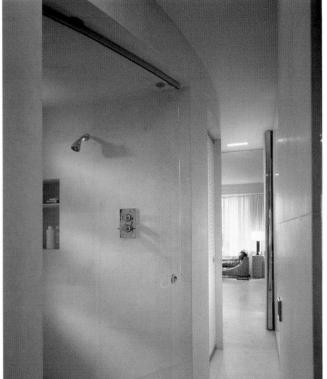

Built halfway through the sixties, the building that accommodates this apartment consists of different levels with simple apartments situated above unbecoming ground floor spaces containing offices and restaurants.

The apartment originally consisted of a studio linked by a staircase to the bedroom and the terrace. The spaces were badly conceived due both to the awkward position of the stairs and the excessive dimensions of the terrace in comparison to those of the apartment. The interior space was extended upwards and outwards to provide views over the east and west ends of London. The layout of the apartment was inverted, placing the kitchen and living room on the floor above, while the bedroom, entrance, bathroom, and studio were located on the ground floor. Thus the apartment was completely

remodelled, including parts of the facade (the windows were replaced by sliding doors), and heat insulation was installed in the roof.

In general, the space was modified by simulating an increase in space through the strategic location of mirrors. Similarly, the definition of details contributed to creating the sensation of greater space. Thus frameless windows and light from above seem to prolong the walls, making them float outwards.

The definition of space has been achieved subtly through the differentiated use of materials and without the need to separate rooms. In this way, more contrasts between materials have been created inside the apartment. In a similar way, the materials also unite spaces. For example, the marble at the entrance is prolonged toward the bathroom as if both formed a single unit.

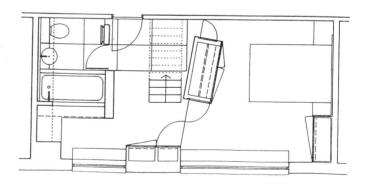

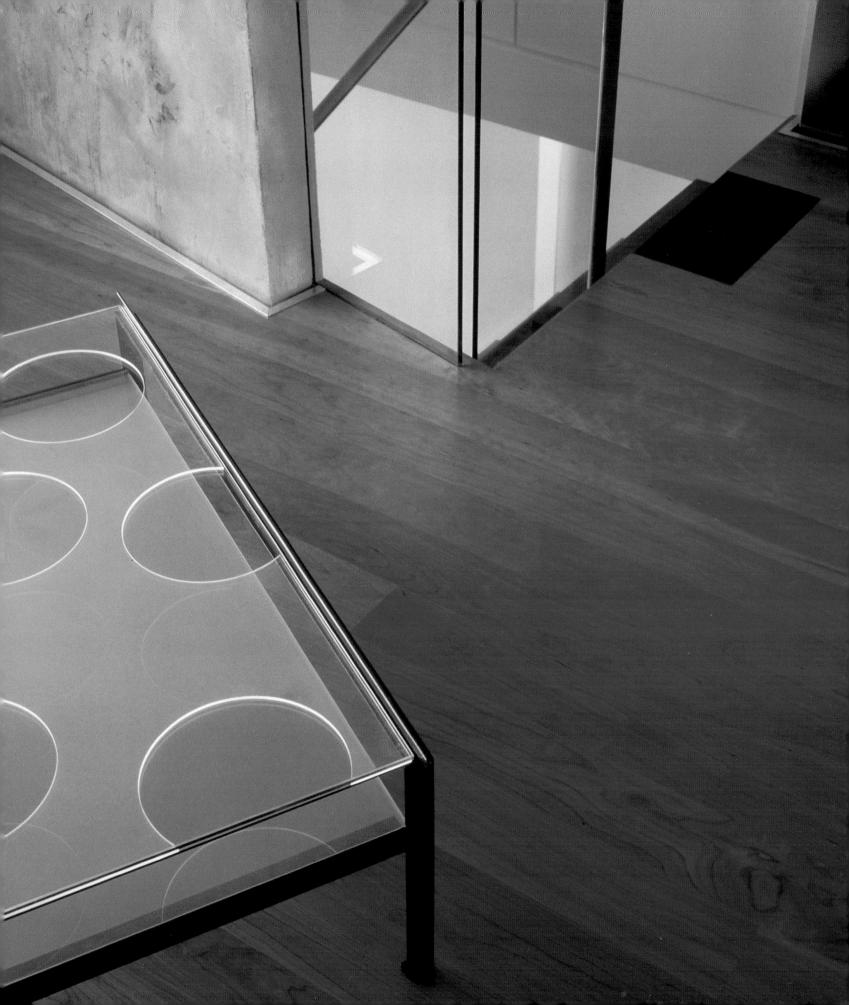

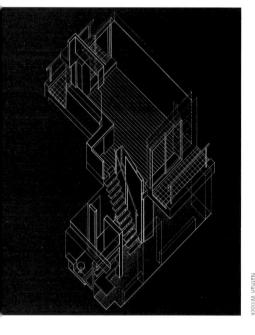

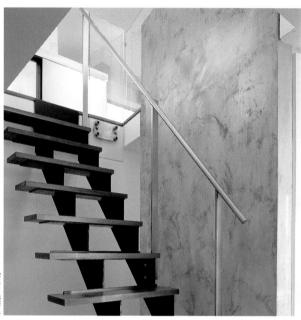

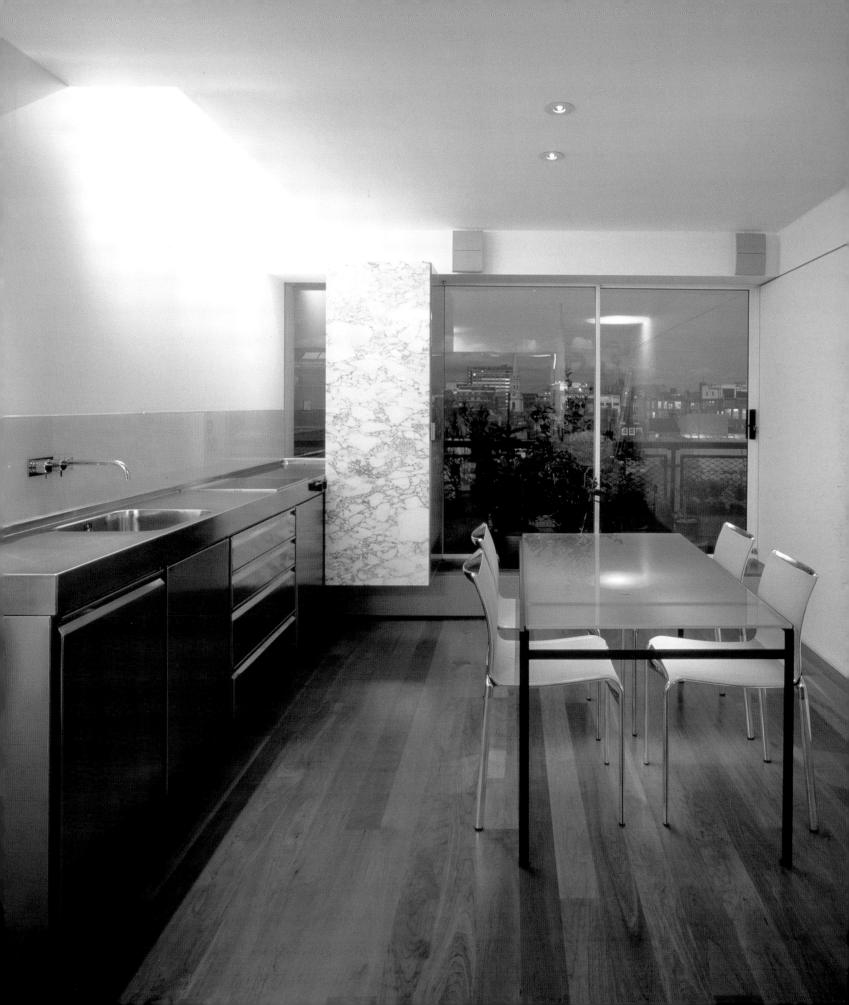

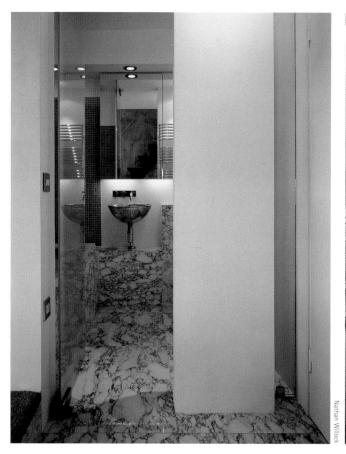

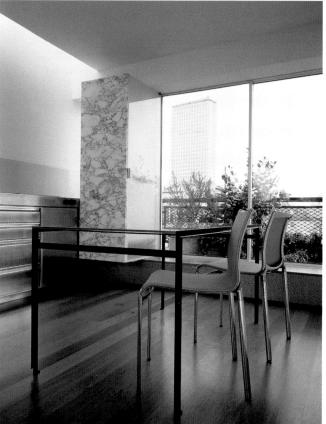

lèlene Bine

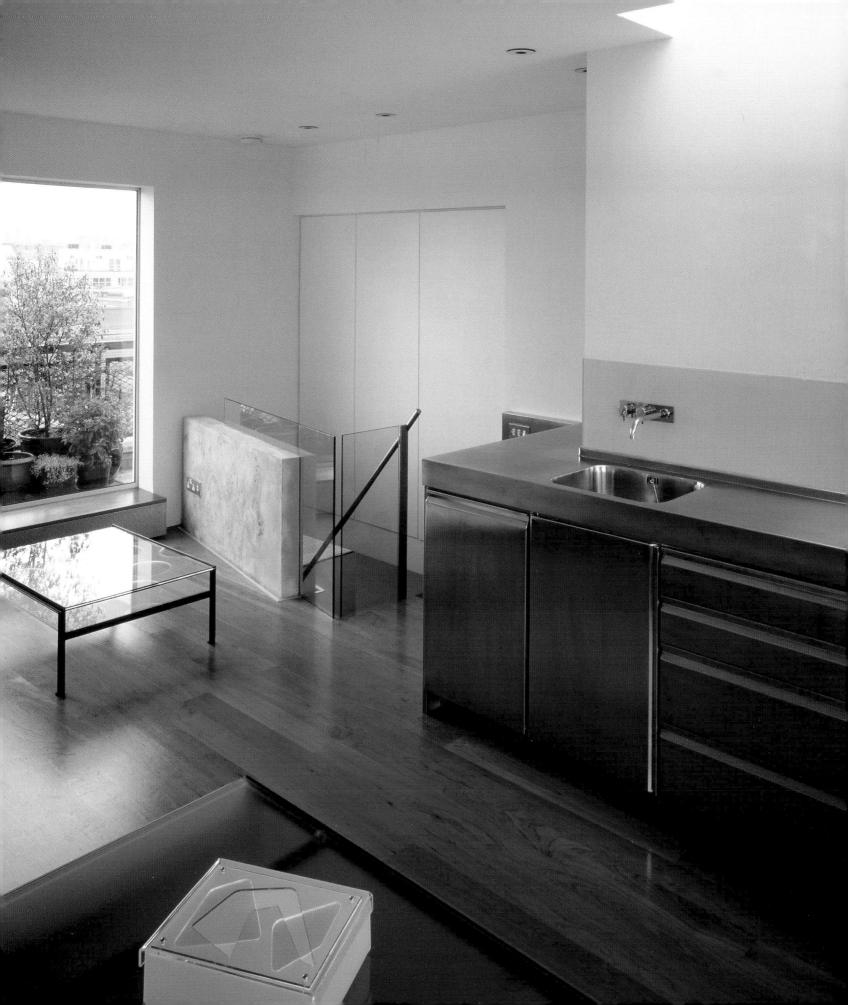

In its original state, the house was rather disorganized as far as services were concerned.

The slight alterations to and extension of the ground floor and the access stairs to the floor above of this house located on the edge of the old centre of Vidreres, in Girona, attempts to solve the problem of the inconveniences arising from the daily use of these services.

The intervention took the form of slight displacements of the walls, a large opening, and a skylight. These three elements were designed to impose order on both the services areas (kitchen, larder, washroom, and small bathroom) and the living spaces (living room, dining table area, and fireplace, elements all arranged around a central marble wall).

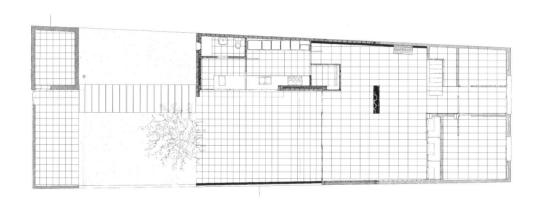

Josep

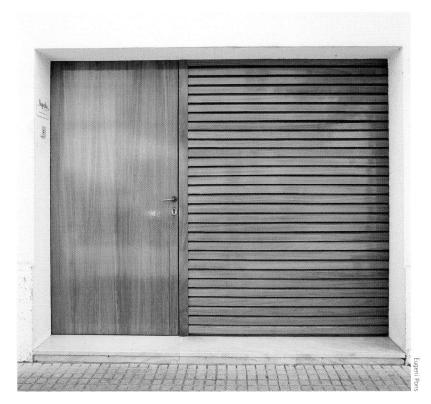

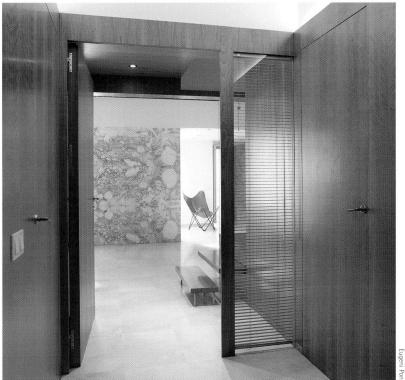

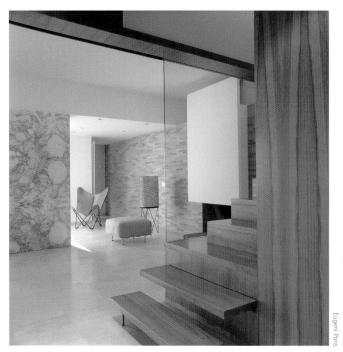

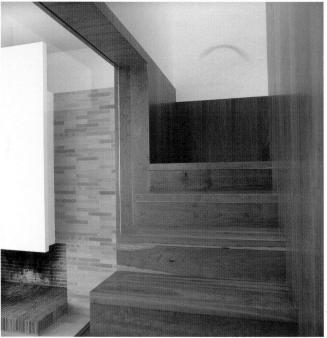

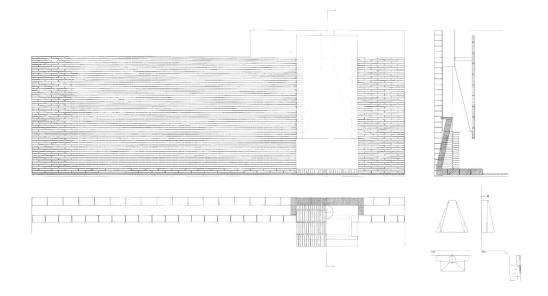

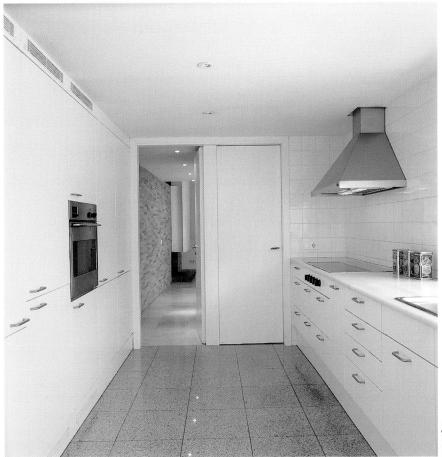

Pons

This dwelling in the Balearic Islands is halfway between a traditional construction and a sophisticated contemporary house. The owner based his work on an old project and designed most of the elements that constitute the building. The distribution is based on a conventional program: the ground floor accommodates the daytime zone and a guest room, while the master bedroom is on the second floor. The visual division between the different spaces is by means of walls or openings in them: changes in section that make it possible to subdivide the room, creating different ambiences.

Special emphasis was placed on the surface finishes, the range of materials was reduced and a limited color palette applied. The interior partitions are stuccoed and the floors are continuous stone. There are no tiles, not even in the bathroom, where the floor, including the shower, is of polished pebbles. The project is coherent thanks, in part, to the furniture, which is almost entirely built-in.

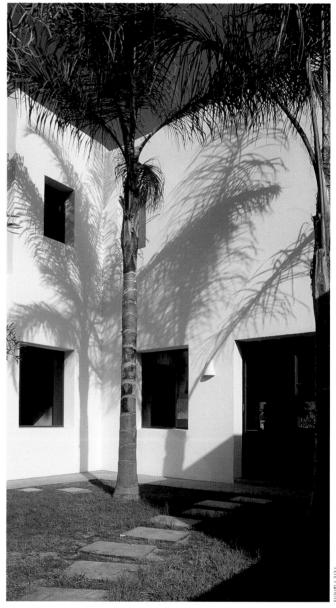

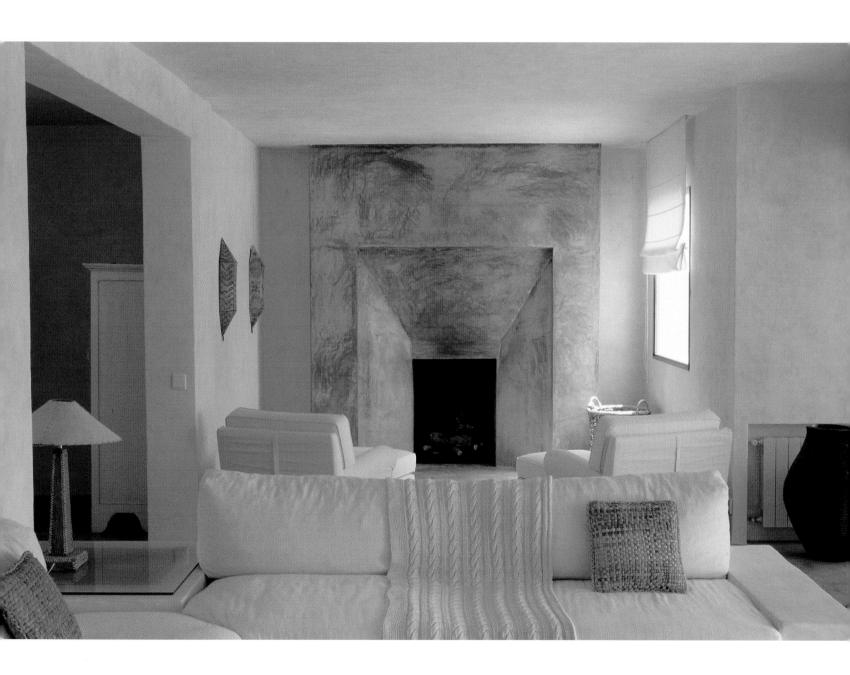

The living room is visually related to the kitchen and the exterior spaces surrounding the house.

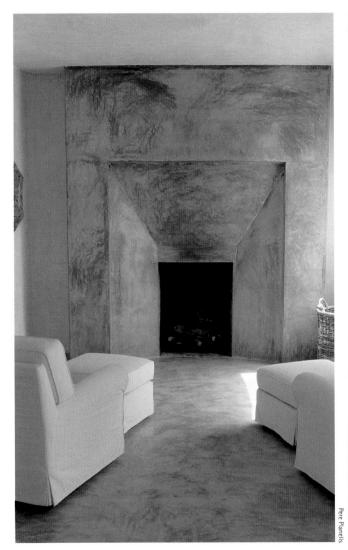

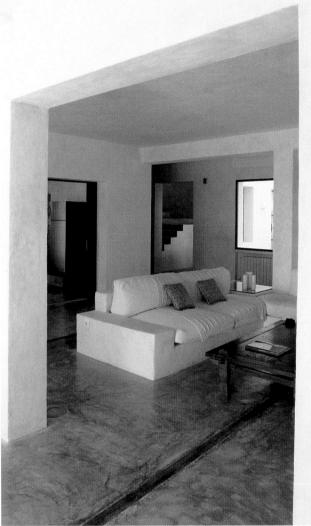

The rustic furniture contrasts with the more refined forms, although it creates no clashes in a varied, harmonious ambience.

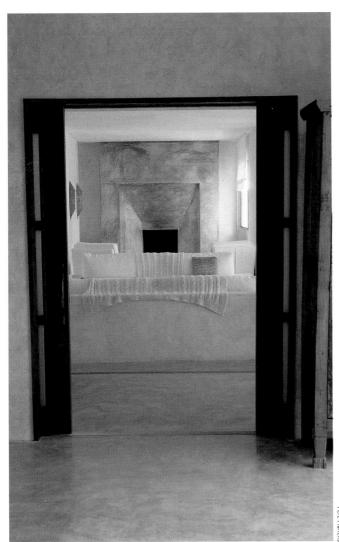

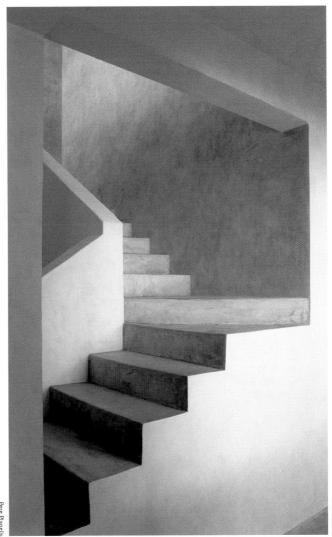

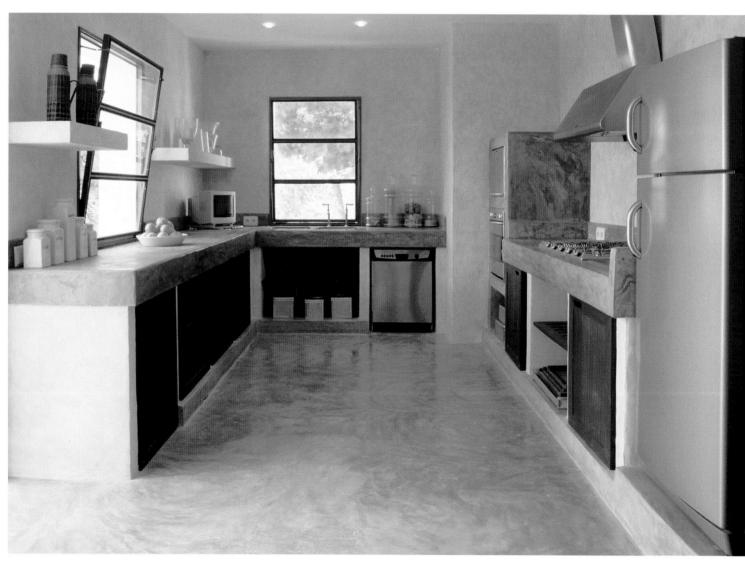

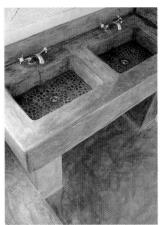

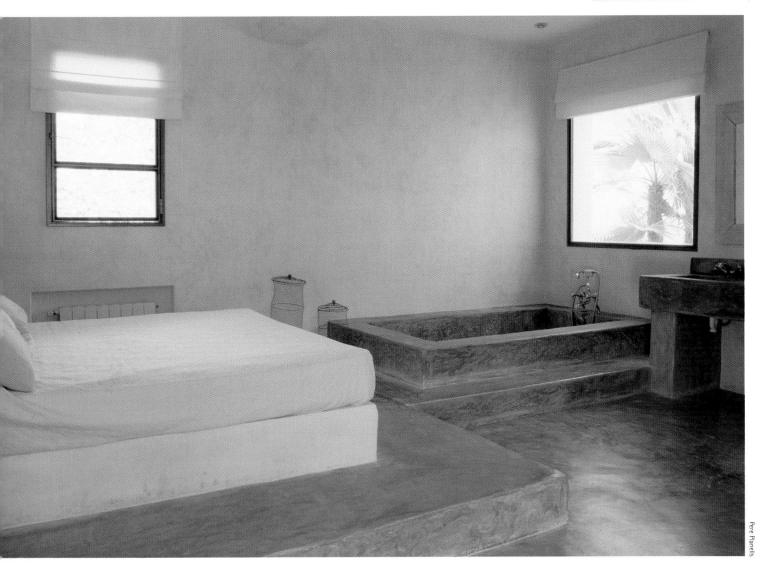

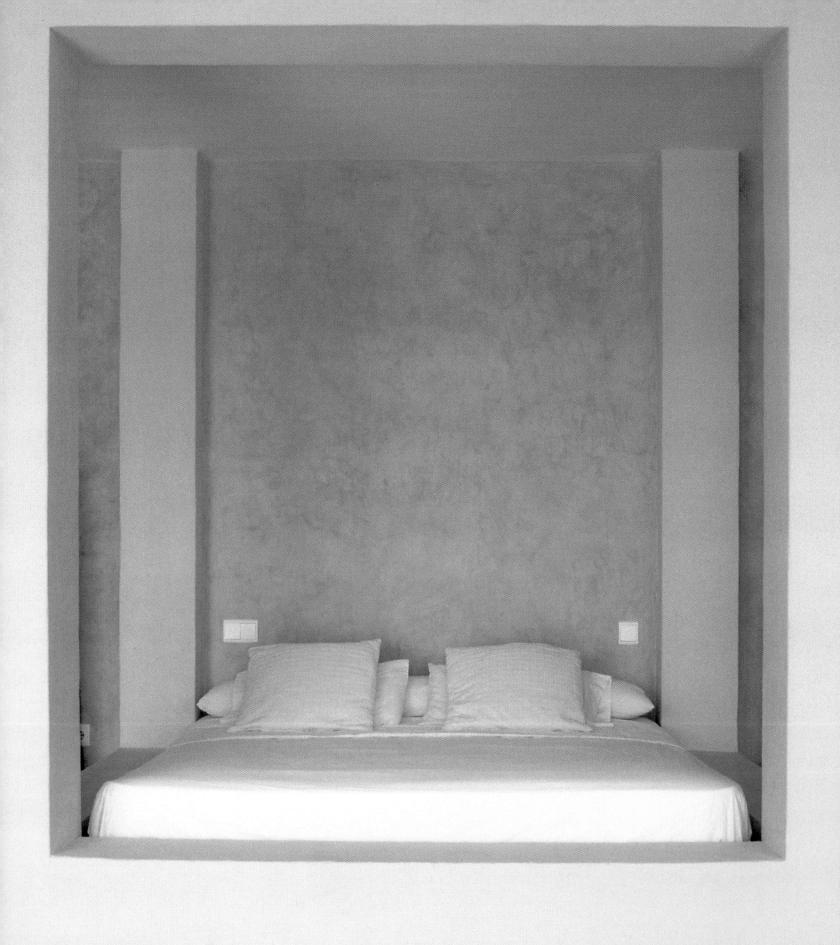

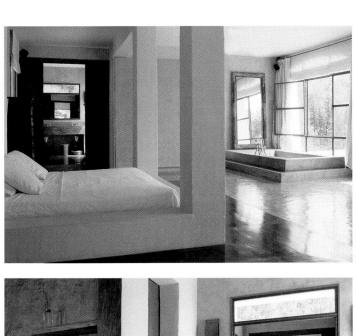

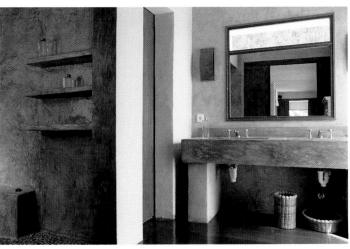

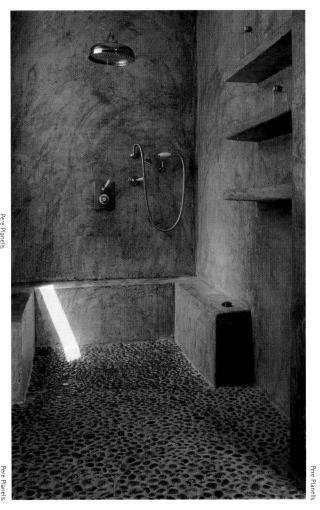

At first sight, the singular quality of the house seems to reside in its entirely monochrome ambiences. However, what is outstanding about the project is the ambiguity of its spaces in terms of location. The inner rooms are entirely permeable from the visual point of view: interrelated and open toward the exterior, they allow no introspection of any kind. Similarly, the patios are conceived as interiors: they are precincts enclosed by walls that isolate them from the immediate landscape.

On the exterior, the dwelling reflects the wisdom of the vernacular and incorporates elements of traditional architecture that protect it against the inclemency of the weather: thick walls provide thermal inertia; the walls are whitewashed to reflect the sun's rays; and openings are preferably on the shady side. On the other hand, the interior — including the patios — has a contemporary, almost futuristic, air. The furniture combines white and a wide range of ochres, and includes pieces of exclusive design. The kitchen is a piece of furniture that opens into the living room, which is characterized by pure lines, formal restraint, and the immaculate white of the smooth surfaces of the cupboards.

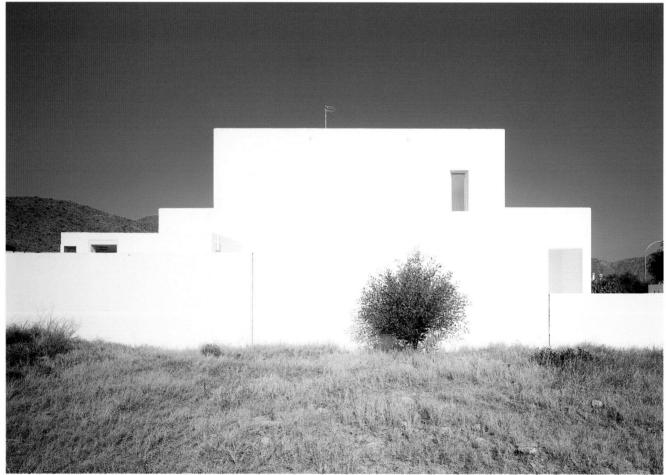

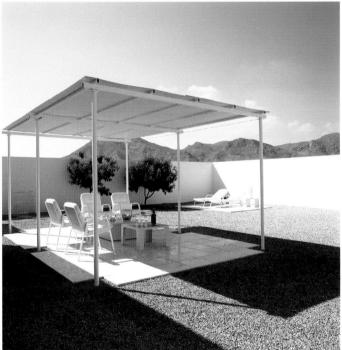

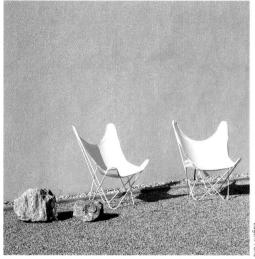

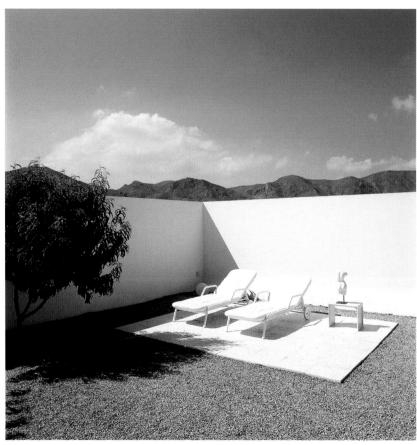

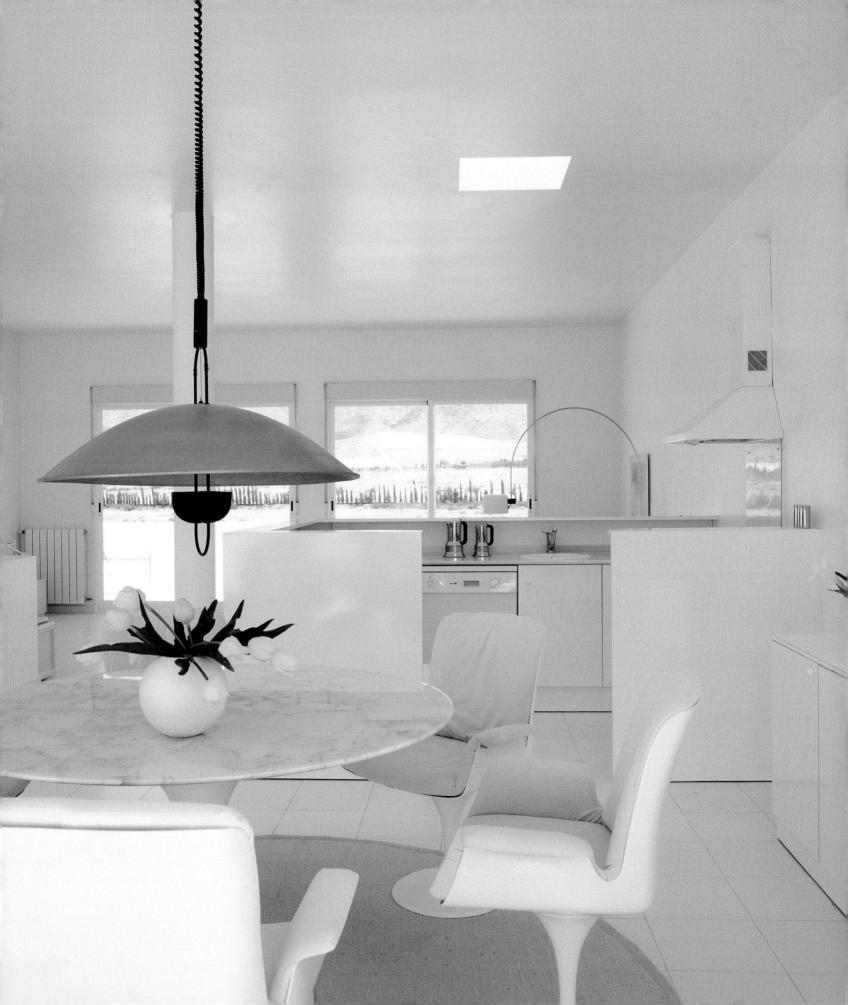

The openings on the facade, the skylights, and the tones of the furniture confer luminosity on the dwelling.

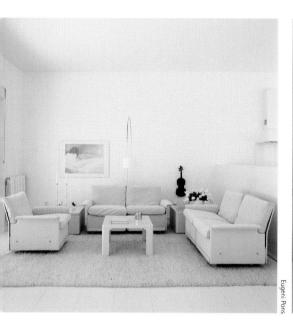

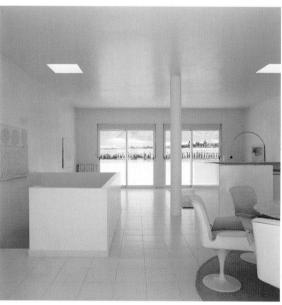

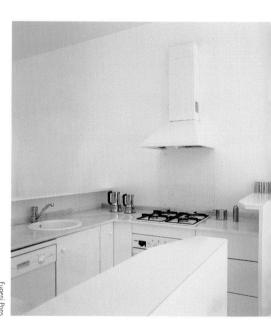

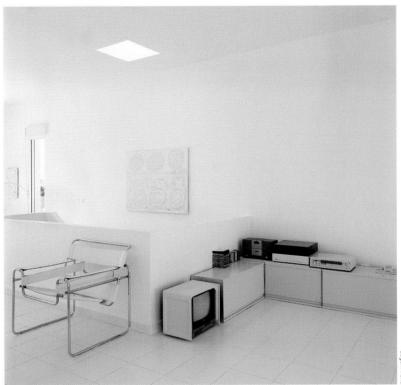

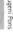

This house stands in the center of Tokyo, in a residential district with big houses, the density of which has increased considerably in recent years. The plots in general have a surface area of around 2,160 square feet. The facade overlooking the street is oriented toward the south, and for this reason many houses on this side feature large windows. Paradoxically, the curtains are almost invariably drawn and high fences ensure privacy inside the homes. Given these circumstances, the architects decided to bring the exterior inside, while ensuring the privacy of interior spaces.

The clients, a childless couple, required two studios, a guest room, two bathrooms, parking space for two cars, a bedroom for a future child, and a large salon in which to entertain.

The whole site was excavated, thus achieving greater vertical distance up to the street and adjacent buildings. Some rooms that required independence, such as the master bedroom, the guest room, and the garage, were placed at street level. The dining room, the study, and other open spaces were arranged on the floor below in combination with open patios. From here, street noise seems to come from far away, which further contributes to privacy inside the dwelling.

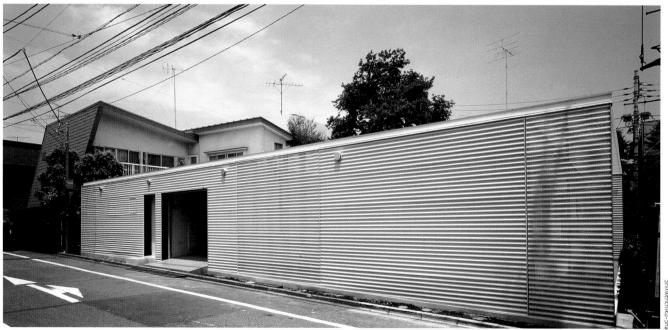

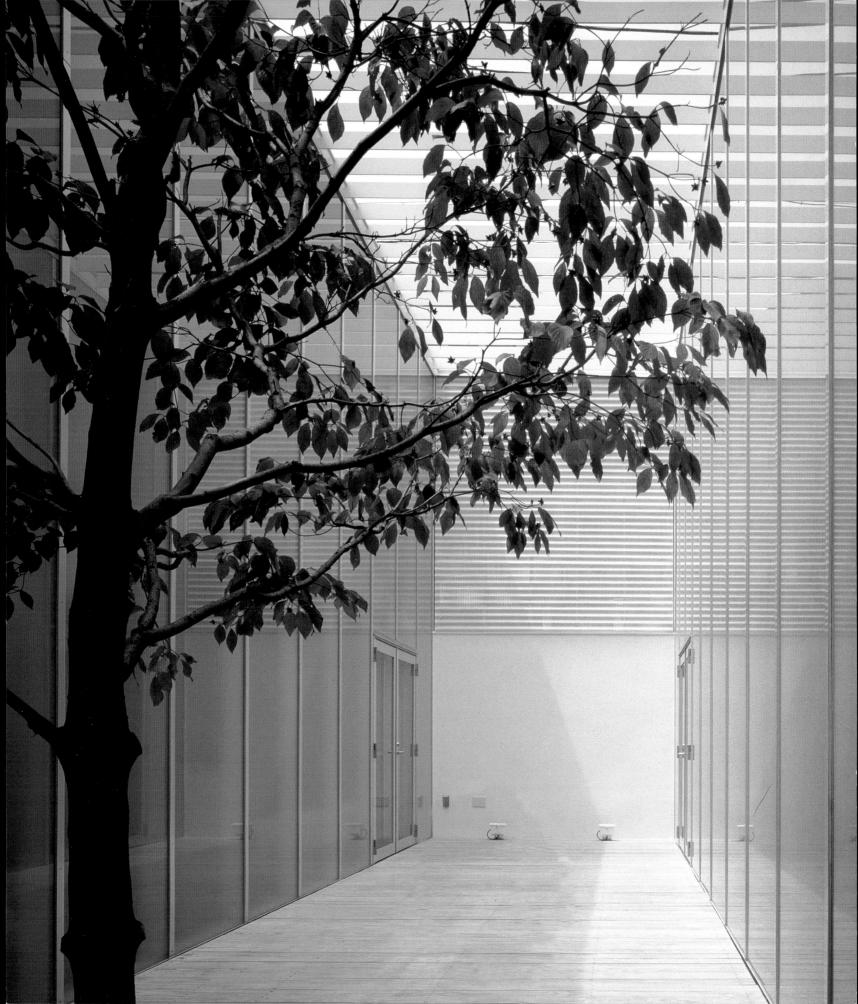

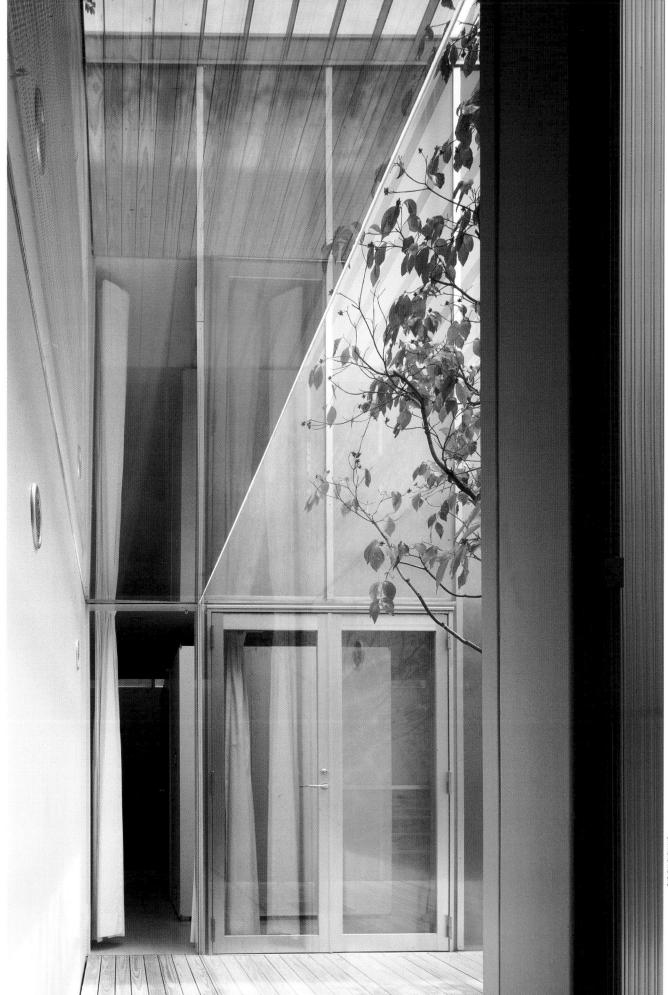

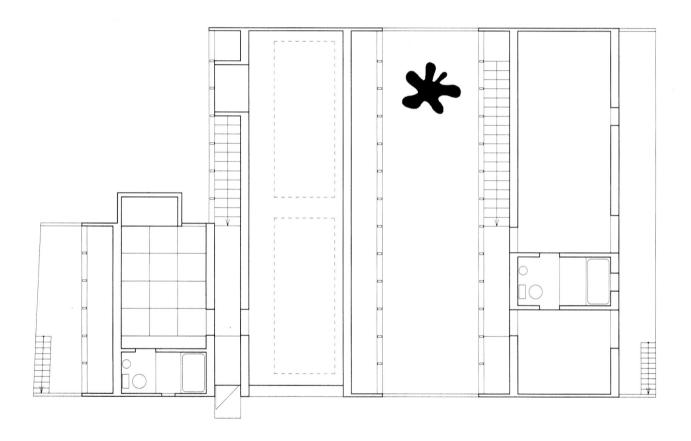

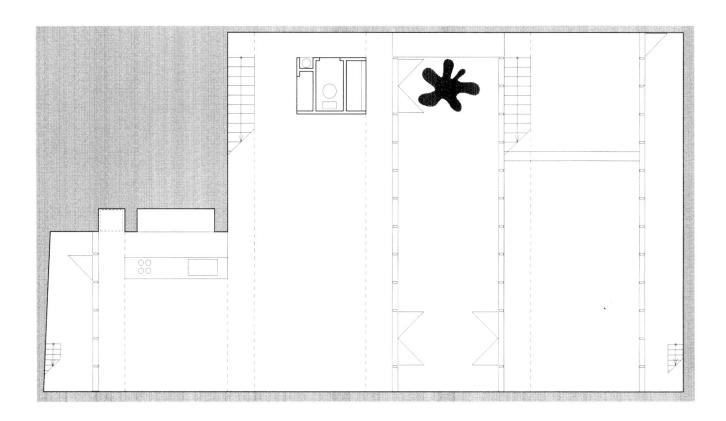

Naked lines, the fruit of having conceived the house in an abstract way, are present everywhere, even in the way the house is represented.

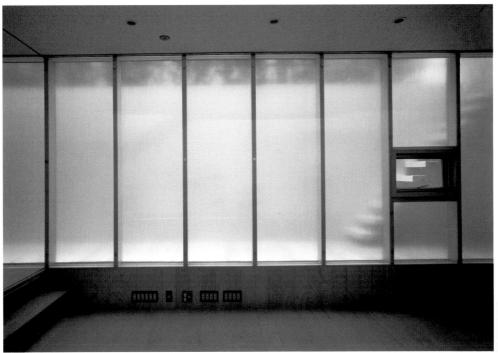

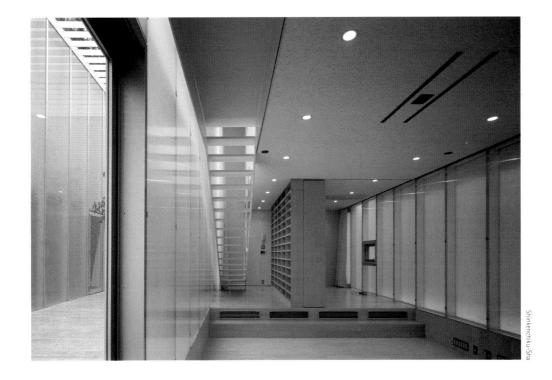

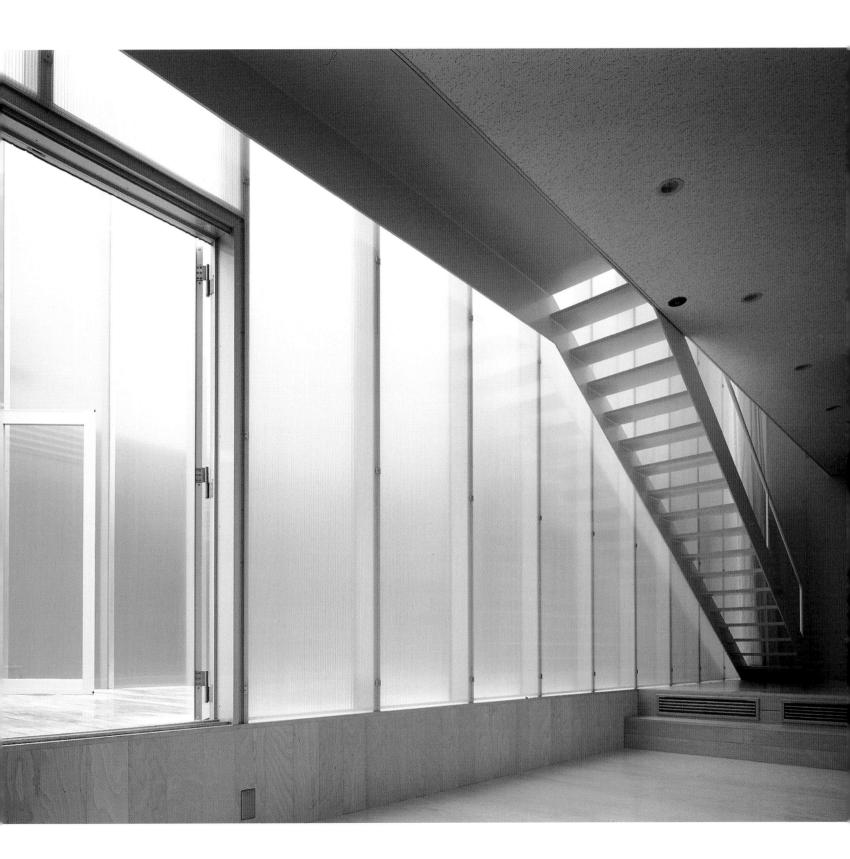

The two story Price/O' Reilly house stands on a site formerly occupied by two, traditional flat roofed houses. The street has a mixture of residential and commercial buildings, including single-family dwellings, stores, and apartment blocks of various sizes and periods. Because this was to be a residential building, the local authorities stipulated that it should resemble a traditional house rather than a store.

For that reason, the main façade is divided into two vertical strips, and both the horizontal elements and the proportions of each of these strips have been designed in relation to the adjacent houses. By contrast, the rear façade consists of a single opening 19.5 feet high by 22.5 feet wide. The interior layout corresponds to this polarity. Behind the main façade are the smaller rooms of the house on two floors: the garage, storeroom, and lavatory (on the ground floor) and the bedrooms and bathroom on the floor above.

Next to the garden a single, double-height space has been built

that functions as the living room, dining room, and kitchen, and when necessary, as a photographer's studio. Since the budget was rather low, the architects opted for a simple structure of steel porticoes with a mezzanine half-floor. The side walls are concrete blocks plastered on the inside. The rear fence, the strips on the main façade and the partition walls are pressed fiber-cement sheets. All the walls were subsequently painted white, while the remaining elements have been treated with a more refined, detailed finish, mostly in matte aluminum.

The rear façade is composed of six 19.5-feet-high sliding glass doors that can be folded up completely against one of the side walls. This not only makes it possible to extend the house to the patio but also to efficiently control ventilation in summer and heat the house in winter by taking full advantage of the sunlight. The eucalyptus that grows on the adjoining edge of the site next door protects the house from the afternoon sun in summer.

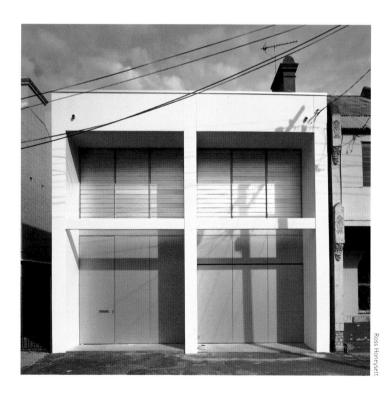

152

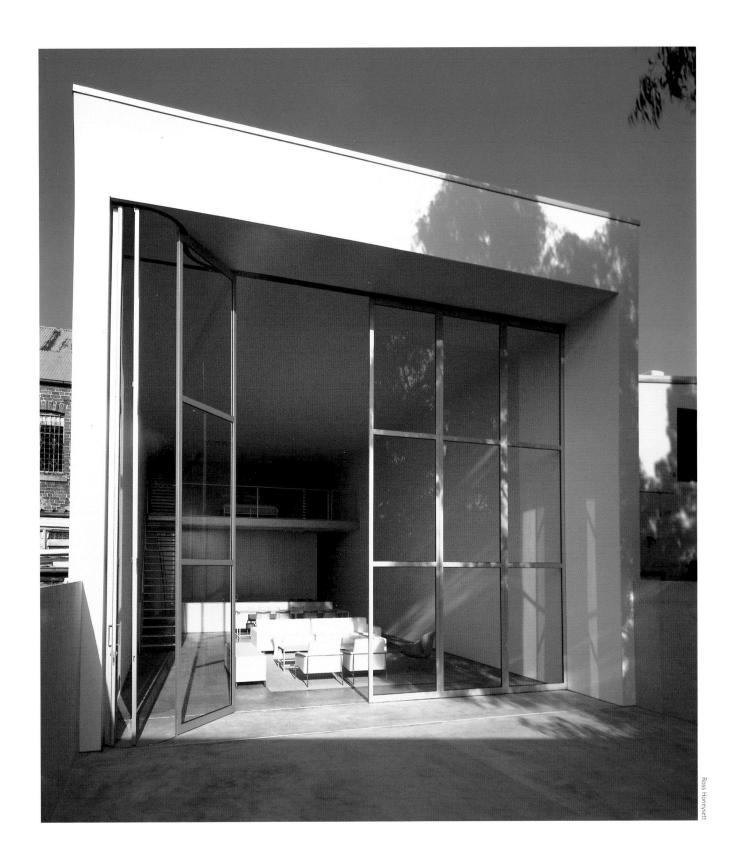

mnm

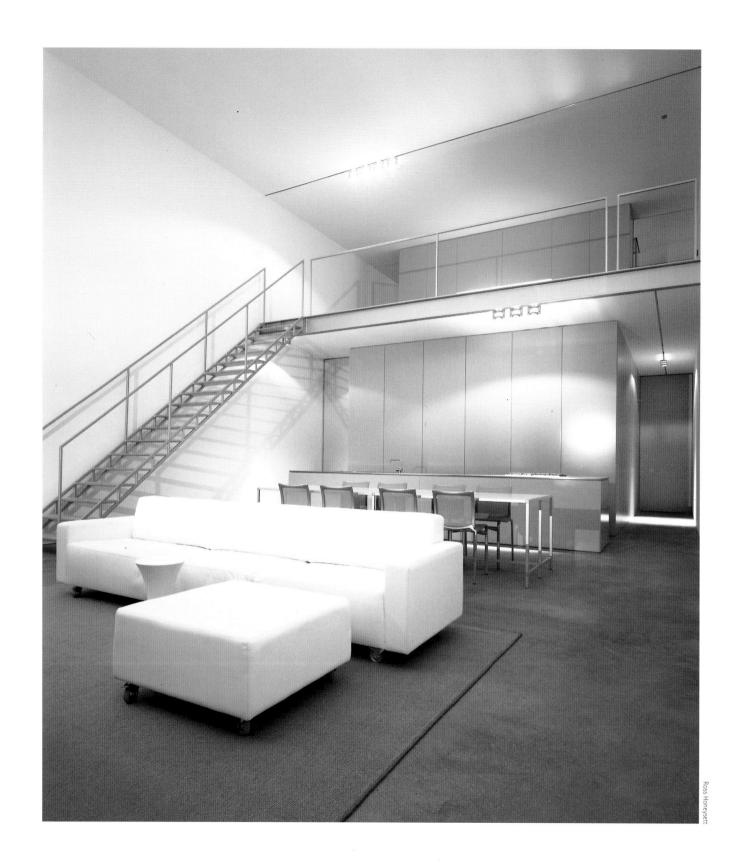

The kitchen is a single piece of furniture beneath the mezzanine half-floor. Not only the dining room and living room tables but also the base of the bed and the towel rack in the lavatory were designed by the architects.

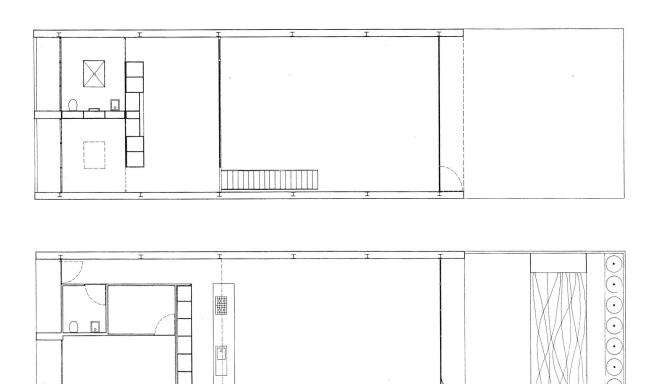

All the furniture had to be lightweight, or else mounted on casters, so that it could easily be put aside to transform the house into a photographer's studio.

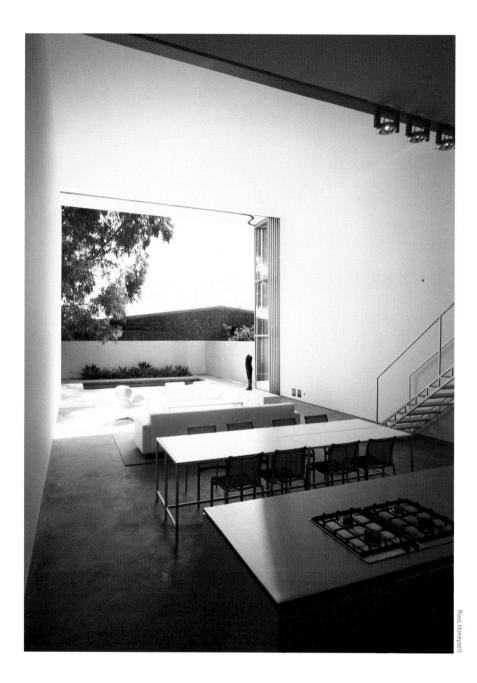

156

The treatment of the finishes and the light endow what is otherwise a very simple geometric space with a whole wealth of nuances.

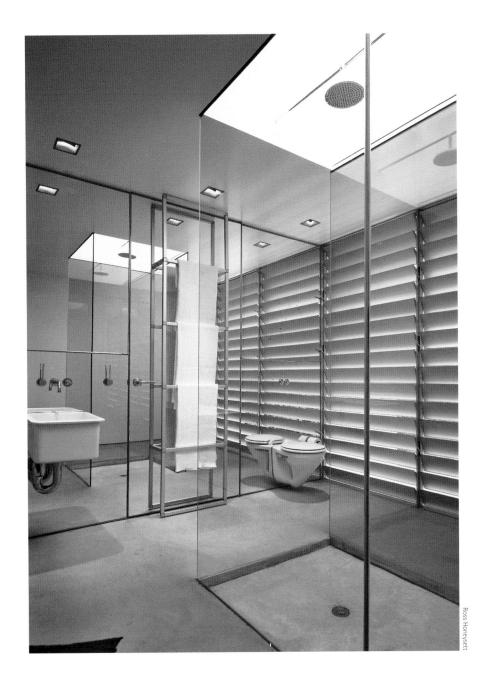

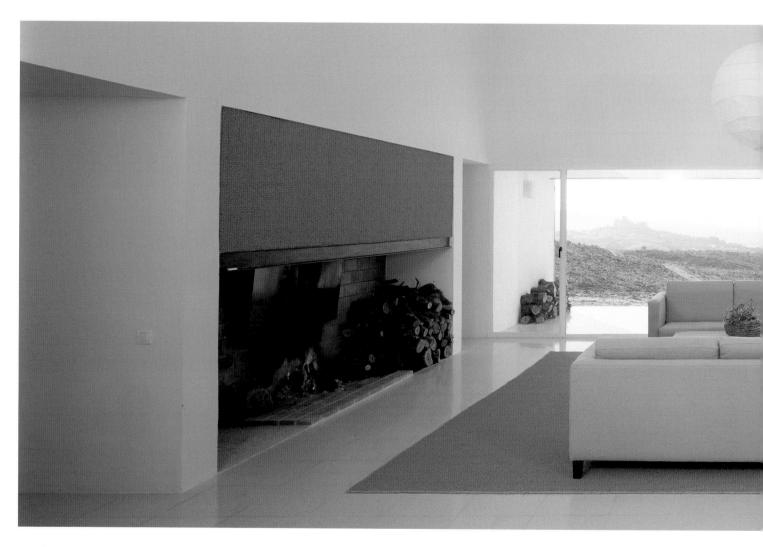

This country house, which stands on a site in the urban nucleus, was designed according to a minimal budget per square foot. From the outset, the main objective was to highlight the exceptional views towards the La Vera valley. Hence it was decided that the main hollow should face west, where the sun sets behind the medieval castle only one kilometre away on the hilltop. After an environmental study had been conducted on climate, site, and the program requirements, a design was developed on two scales. On the one hand, a large common zone that articulates the whole project; on the other, the remaining

spaces serve and give meaning to the rest. The central space, 13.5 feet high, contains the circulations, common uses, main bearing walls, and, of course, the magnificent views.

The apparently prominent east-west axis dilutes when we enter the living area, which opens into a set of wider, lower rooms. In this way, the relationship between interior and exterior spaces is more flowing, and is accentuated by the natural light that comes from the perimetric zones. The exterior volume reflects the constructional system of bearing walls and concrete floor-ceiling structures.

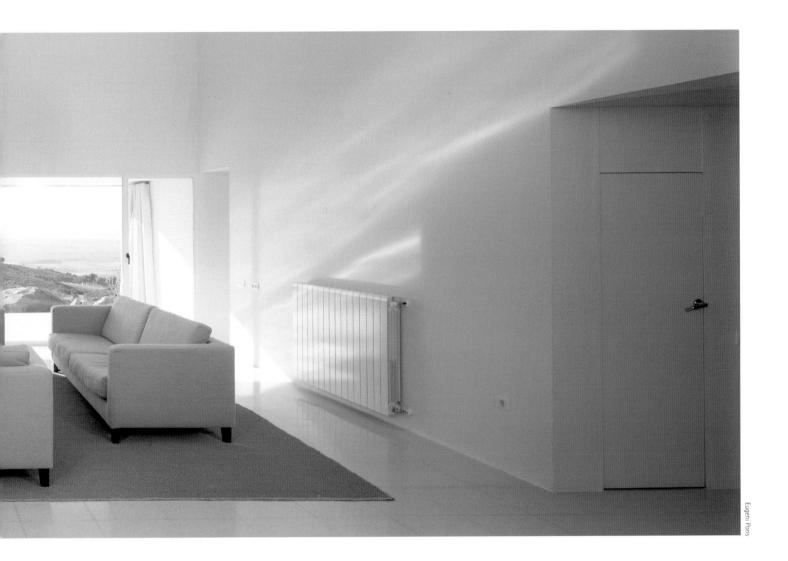

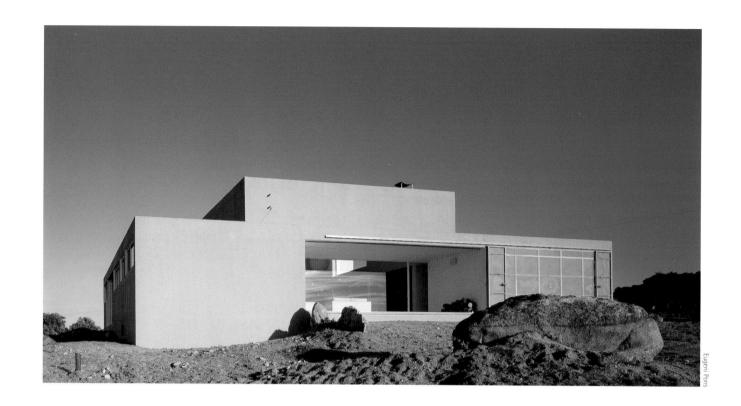

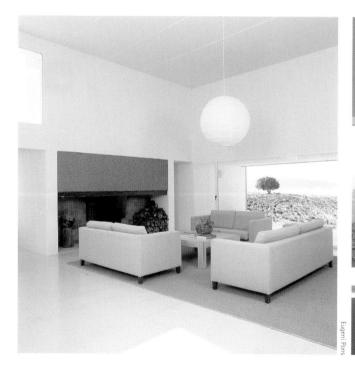

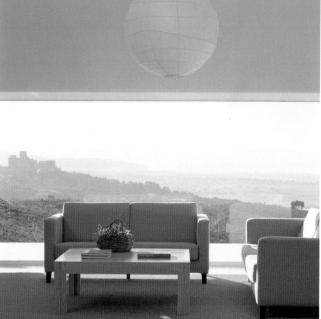

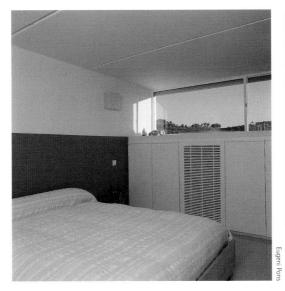

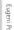

To have at one's disposal a magnificent site, a generous budget, and solicitous clients is no guarantee that the project will be a success. While it is true that all these conditions facilitate the creative process, they may also become traps, causing the architect to be carried away by opulence, by superficial extravagance, and to give way to his most absurd caprices. Vicens and Ramos, however, have managed to avoid these snares and have exploited the advantages of the brief. The result is a house of striking forms and exquisite finishes.

The daytime zone consists of large spaces divided by timber walls that do not reach the ceiling and contain strategic openings that set up specific visual relationships. The finishes differentiate between the roles of the partition: the solid, stuccoed walls perform a structural function, while the timber partitions endow the ambience with warmth. The development of the section is very important in the upper parts of the house, allowing natural light to penetrate from above.

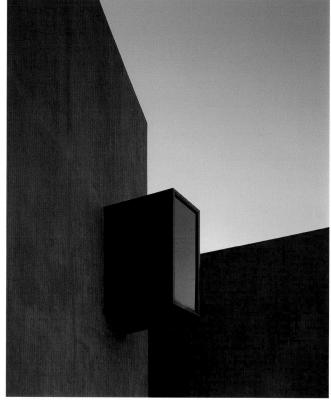

Eugeni P

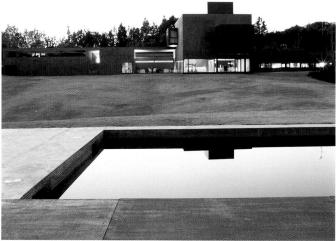

Eugeni Pons

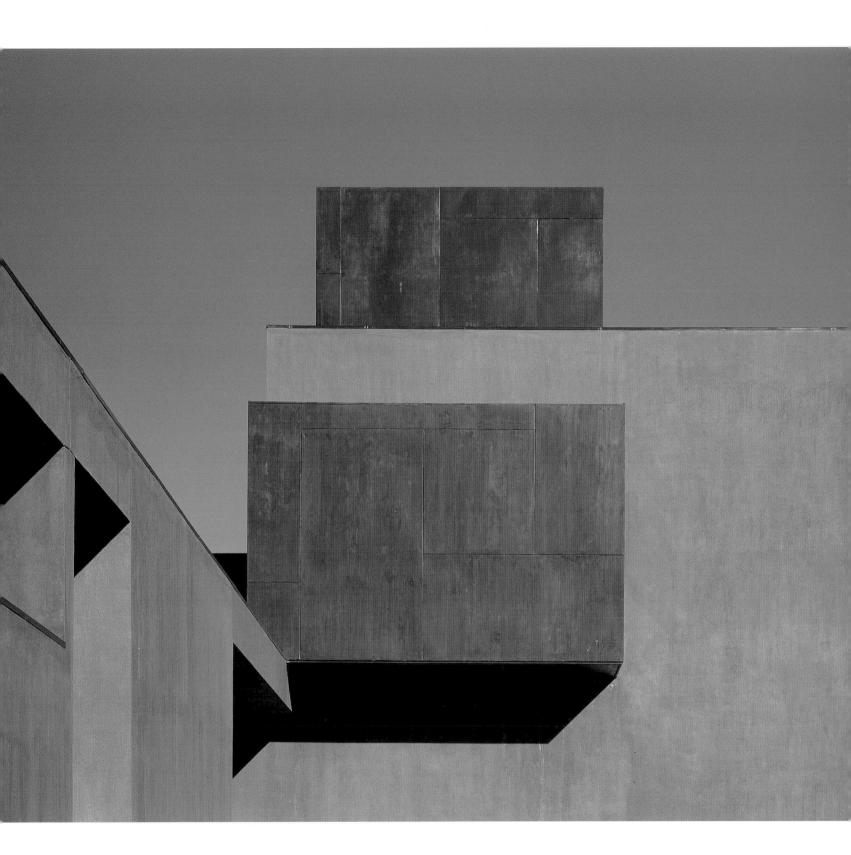

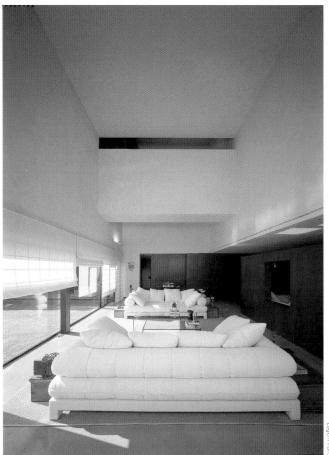

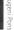

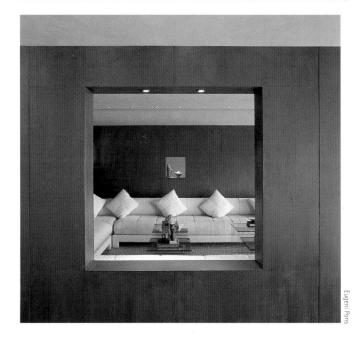

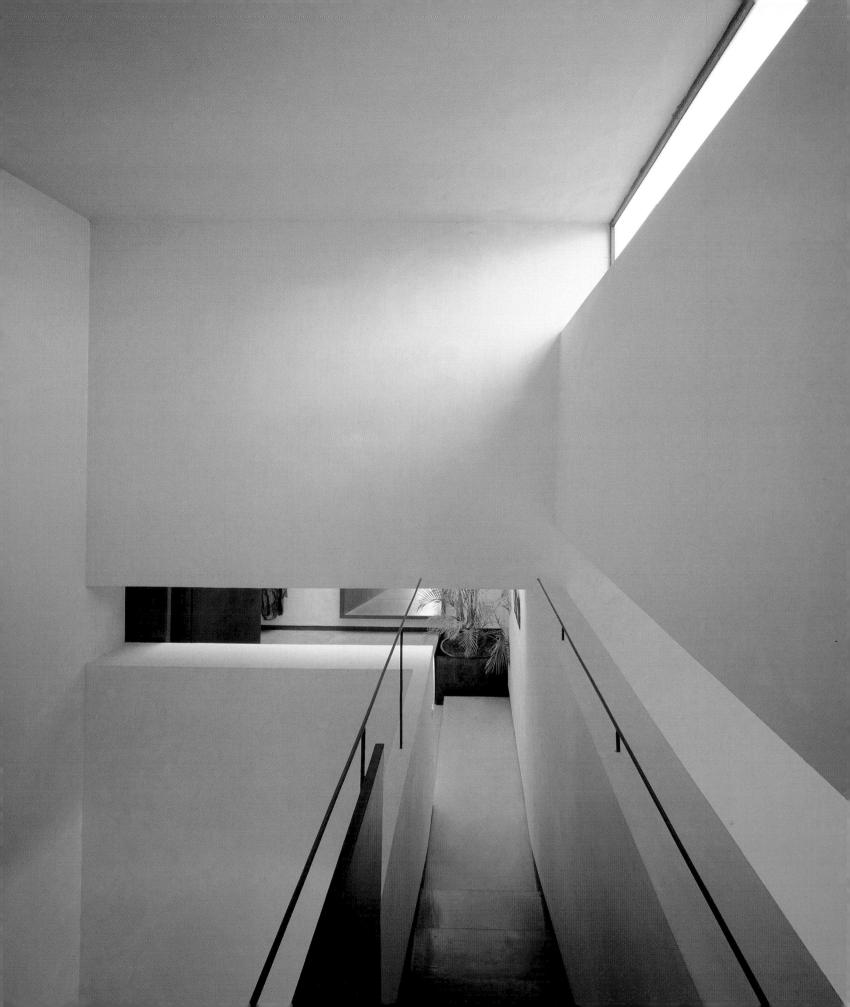

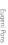

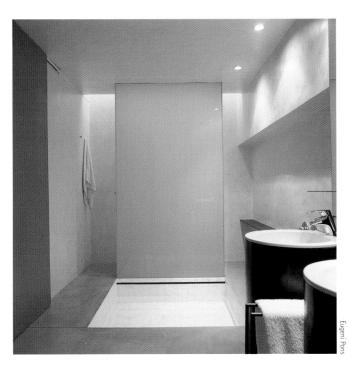

Like the rest of the project, the bathrooms are the fruit of clear, uncompromising decisions: purity of form and changes in section that endow space with character.

This apartment is housed in a building that stands at a certain distance from the city center. Maples and cherry trees provide the landscape with color changes as the seasons vary throughout the year. A small, twenty-year old apartment block has been converted into a pleasant atmosphere in which to live. The exterior appearance of the building was left completely untouched, since any intervention of this kind was ruled out from the very outset. The building stands on a site with a slope toward the north and flanked

by a raised highway. Access to this restructured duplex is from ground level by means of stairs that connect with the road level.

The apartment is conceived as a continuous space, without fixed partitions. The name "3R" alludes to three movable panels placed near the entrance to the apartment. By folding them at different angles, the space may be modified to provide a host of different combinations, depending on the needs and tastes of each resident. The furniture was removed and the walls, floors, and ceilings were painted white to enhance as far as possible the low intensity light that enters from the north. The rooms succeed each other smoothly on both floors, linked by a staircase. The original windows have been screened by translucent plastic panels, forming small spaces that may be used for storage, as a library area, or as a belvedere overlooking the garden.

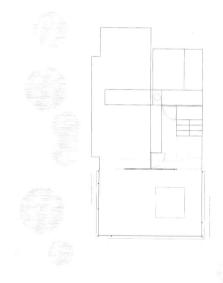

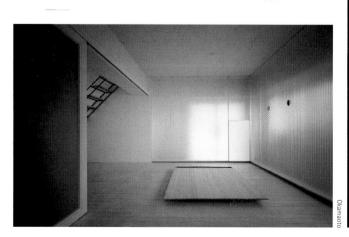

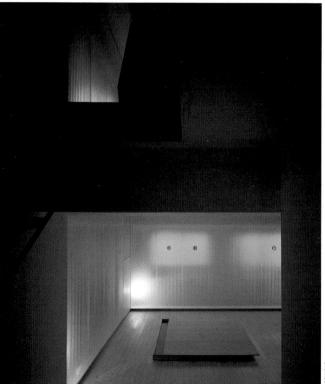

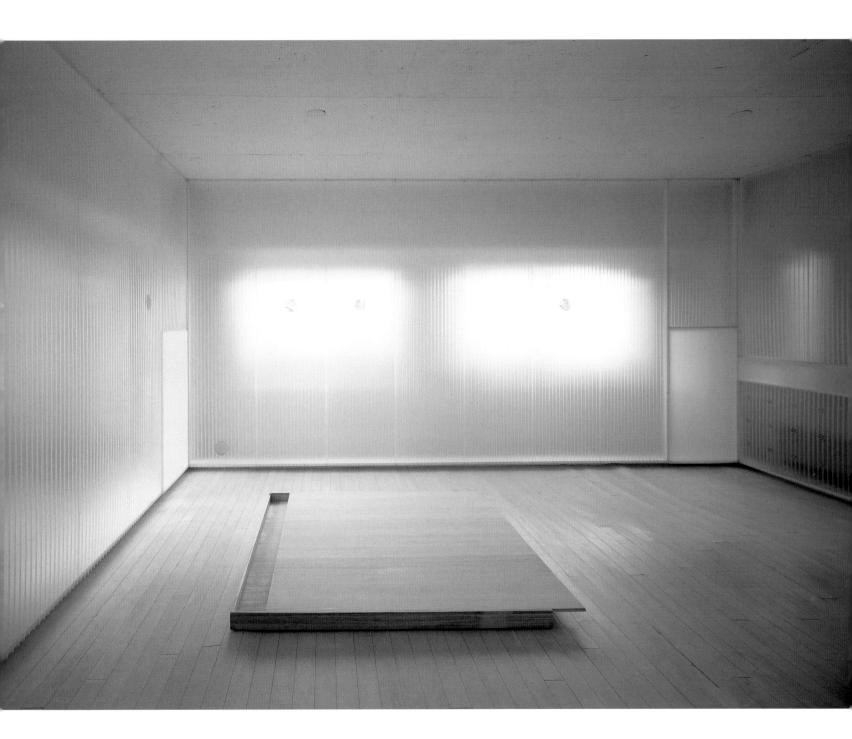

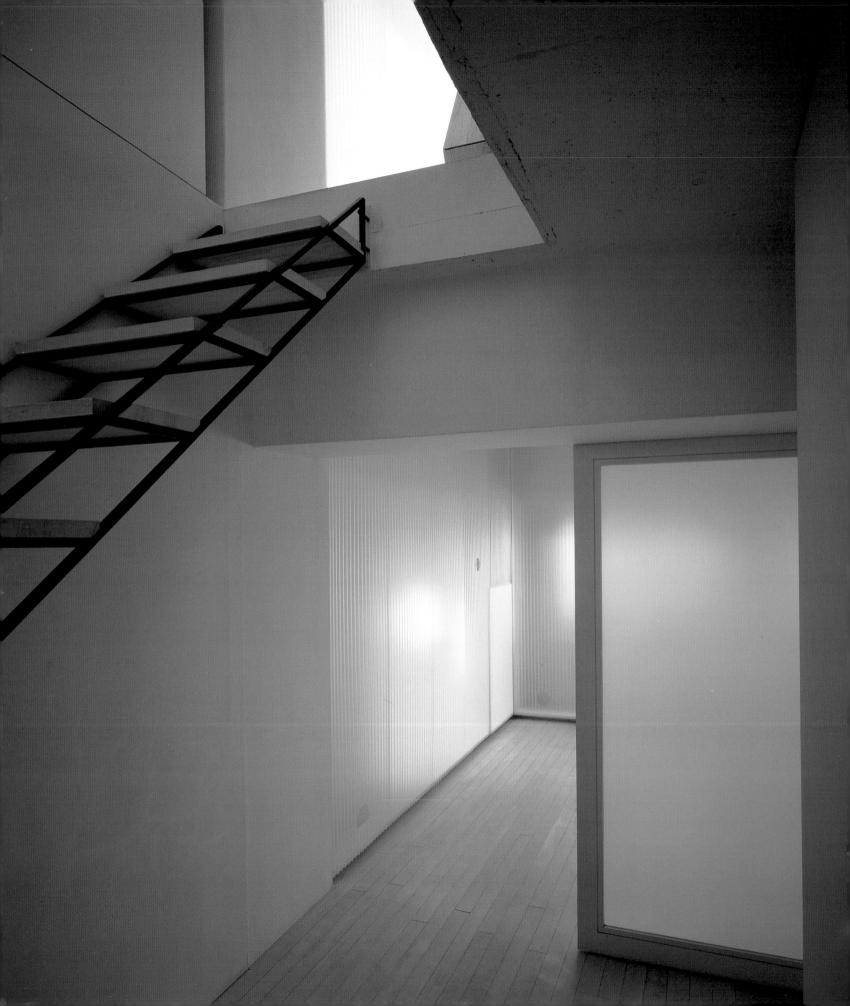

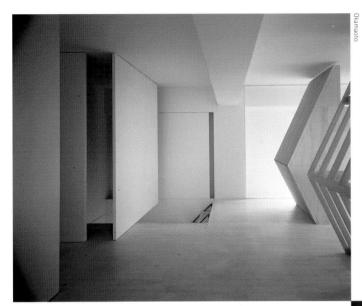

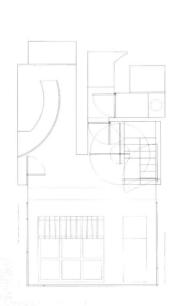

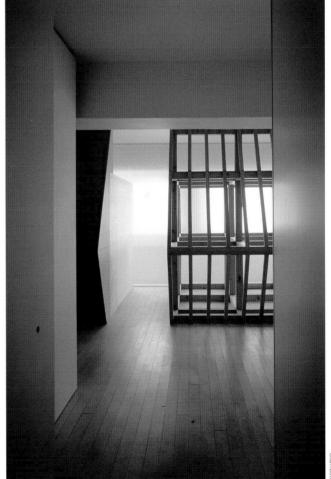

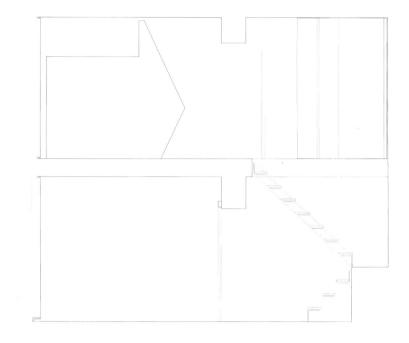

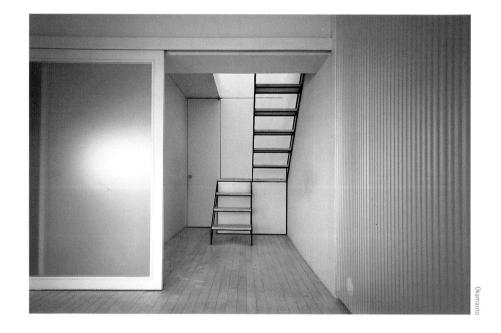

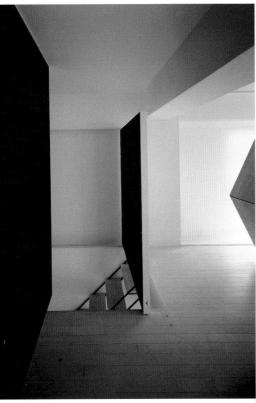

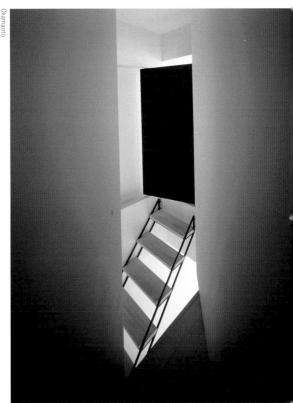

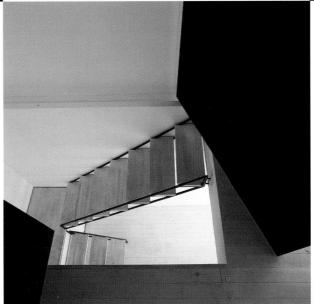

All projects by Hiroyuki Arima reflect characteristic Japanese sensitivity, a combination between tradition and futurism.

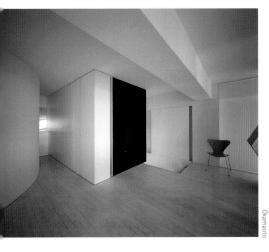

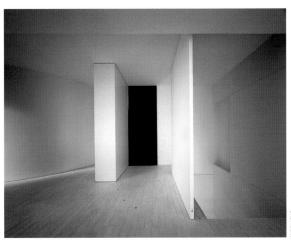

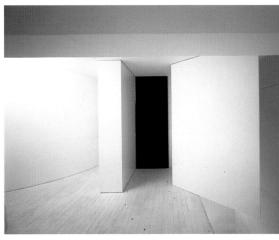

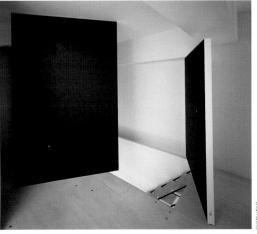

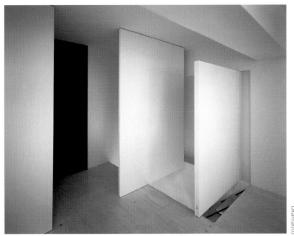

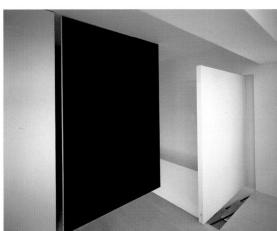